EAVAN BOLAND

POETRY

Night Feed

The Journey

Selected Poems

Outside History

In a Time of Violence

The Lost Land

Code

New Collected Poems

Domestic Violence

New Selected Poems

PROSE

Object Lessons

A Journey with Two Maps: Becoming a Woman Poet

AS EDITOR

The Making of a Poem: A Norton Anthology of Poetic Forms
(coeditor, Mark Strand)
The Making of a Sonnet: A Norton Anthology
(coeditor, Edward Hirsch)

PAULA MEEHAN

Dharmakaya

Painting Rain

JODY ALLEN RANDOLPH (EDITOR)

Eavan Boland: A Critical Companion

Close to the Next Moment: Interviews from a Changing Ireland

A POET'S DUBLIN

EAVAN BOLAND

EDITED BY

PAULA MEEHAN AND JODY ALLEN RANDOLPH

With photographs by Eavan Boland

W. W. NORTON & COMPANY
Independent Publishers Since 1923
New York | London

First American Edition 2016

For information about permission to reproduce selections from this book,
write to Permissions, W. W. Norton & Company, Inc.,
500 Fifth Avenue, New York, NY 10110

For information about special discounts for bulk purchases, please contact
W. W. Norton Special Sales at specialsales@wwnorton.com or 800-233-4830

Manufacturing by Versa Press, Inc.
Book design by Chris Welch
Production manager: Louise Mattarelliano

ISBN 978-0-393-28536-9

W. W. Norton & Company, Inc.
500 Fifth Avenue, New York, N.Y. 10110
www.wwnorton.com

W. W. Norton & Company Ltd.
15 Carlisle Street, London W1D 3BS

1 2 3 4 5 6 7 8 9 0

ACKNOWLEDGEMENTS

We owe thanks to Kevin Casey for his help and counsel, and to Theo Dorgan who was there at the project's inception and provided valuable feedback as it developed. For permission to use the photographs featured in this book, we are grateful to Eavan Boland.

For supplying objects or images featured in the photographs, we are grateful to the following people:

Eavan Boland, for Oisin Kelly's wood sculpture *The War Horse*, used with the poem 'The War Horse', and for Frances Kelly's oil on canvas, *Child with Doll*, used with the poem 'The Dolls Museum in Dublin'.

The Drummond family, for the dance cards belonging to their grandfather Dr Maurice Drummond, used with the poem 'How the Dance Came to the City'.

Patrick and Marie Shortt, for the permission to photograph Eavan Boland's childhood home, which appears in the photograph alongside the poem 'We Were Neutral in the War'.

The short prose excerpts from 'Writing the Place' appeared in *Eavan Boland* (Contemporary Authors, volume 207; Farmington, Michigan: Gale, 2003).

CONTENTS

II
GIFTS OF THE RIVER

III

UNDER THESE HILLS

INTRODUCTION

What gives cities their unique identities? As this book will suggest, a city gets its identity not just from its buildings, its industries, its history, its public events and its notable citizens. It also finds its identity from being imagined. The years, decades, centuries in which a city shapes its inhabitants add up to a rich life and afterlife of meaning and memory. Those meanings and memories require language and expression.

Just as it would be difficult to imagine a country without its cities, it is also hard to imagine a city without its poets. Taking Sandburg out of Chicago, or Baudelaire out of Paris, or Hart Crane out of New York, or subtracting Wordsworth from London wouldn't just silence a definition of origin. It would also disrupt the traffic between language and place that is at the heart of poetry.

Paula Meehan and myself were keenly aware of the vital relationship between poet and city, between language and place, when we began shaping this book. Having reflected on them for many years, we knew Eavan Boland's Dublin poems were

central to her work. We also understood that poets both find and give identity to the city by imagining it. As Paula Meehan recently explained, 'The relationship with the city is one of the central relationships of my life. And I read Eavan Boland as one of the great poets of Dublin – of the statues, of the buildings, of the bridges, of the river'. As editors, we imagined this book as a topography of the city with the poet in particular places at different ages and phases of her life.

The city Boland first named and narrated as a young poet in the early 1960s was well mapped in literary terms. It had been imagined by a formidable succession of Irish writers, from James Joyce to W. B. Yeats, from Seán O'Casey to Thomas Kinsella. Over the next five decades Boland would map the city on her own terms, exploring many Dublin cityscapes in her poems. This mapping culminates in 'Anna Liffey', where the poet, like the river and its namesake, claims the agency to name and narrate the city as a woman. The poem ends with another claim, another intervention: 'In the end it will not matter that I was a woman'.

Yet looking at women poets, one is struck by how few have been urban poets. How few women poets have been comfortable trying to make a text and context of the city. However, Eavan Boland and Paula Meehan are just that: two preeminent city poets who have made the city central to their work and whose work has become central to its identity. For Boland this was a pilgrim's progress. When she returned from a childhood in London and New York, Dublin seemed, with its Georgian architecture and its statues of heroes, like a 'history lesson'. But city and identity, though intertwined imagina-

tively, could also be oppressively silent. Many of her earliest poems were 'intended to confront the silence of a city with the life one woman lived within its limits'. As the young poet explored more of her imagination, she discovered more of the city: 'I could engage it on the same terms I engaged my life as a poet: as a debate with power, with exclusion, with the set text of cultural dominance, with the passing nature of exigency and power'.

When she married in her mid-twenties and moved from city to suburb, Boland put her new life into conversation with the city's powerful literary traditions: 'It has to be remembered – and I suppose time passing erases things like this – that it looked like affront back then to put my life in a suburb into a dialogue with a city of history and expression like Dublin. But just as a city wants not to acknowledge its suburbs, I was aware that a literature wants not to acknowledge its margins'. The poem 'Anna Liffey' forces that dialogue, but from the doorway of a woman's house, 'something unimaginable in the early literature about Dublin'.

Poems that bring a woman's life to the definition of a city are what drew us, as editors, to this project. But we were also drawn to the ability of Boland's poems to reach beyond their Dublin setting. The poems here imagine a city shaped by the pressures of colonisation, of Europeanisation and of globalisation, following Dublin from 'an inland coast so densely wooded / not even the ocean fog could enter it' to a city 'lost under an onslaught of steel'. It is to this changing place that 'An old Europe / has come to us as a stranger in our city, / has forgotten its own music, wars and treaties, / is now a machine

from the Netherlands or Belgium'. A poem like 'Atlantis – A Lost Sonnet', which opens this volume, is set in the very far past and in the realm of myth, and yet invokes the present-day fears of all city dwellers, not just those on the vulnerable edges in Venice, New Orleans, New York and Fukushima: 'How on earth did it happen, I used to wonder / that a whole city – arches, pillars, colonnades, / not to mention vehicles and animals – had all / one fine day gone under?'

In order to suggest how Boland has imagined the city, we chose to organise the poems topographically rather than chronologically. By organising the poems into three sections representing city, river and suburb, we highlight them here as explorations of a very particular city, a city never exactly owned and never completely lost: a city imagined through absence and architecture, through women and colony. A city which at times seems on the verge of becoming a ghost city, but one that is always pulled back into the moment by the powerful language and clear attachment of the poet.

But we wanted to do more than just suggest the ways in which a poet has imagined a city over a span of four or five decades. We wanted to sketch out a paradigm for *how* a city is imagined. To this end, we envisioned a series of suggestive dialogues between text and image, and between poet and poet. We attended carefully to connections between the poems included here, and to connections between the poems and the photographs taken by Eavan Boland that, as Paula Meehan aptly described them, create 'a doubling of the vision'.

The connections between the poems and the photographs are not always obvious. At times they look more like disjunc-

tions. To put a lyric poem of place next to a contemporary image of a bridge or a traffic jam or a pepper pot might at first seem a jarring contrast. But looked at more closely, the pairing of poems and photographs reveals something important – that an imagined place is never static but always in process, always slipping away from its last definition into its next adventure of being imagined.

Our next dialogue was between one city poet and another. We decided on a conversation between Eavan Boland and Paula Meehan, whose iconic Dublin poems like 'The Pattern' and 'My Father Perceived as a Vision of St Francis' have also reimagined the city over several decades. Meehan's poems often step into the shadows of the city, brightening them with detail and purpose. Born at the heart of Dublin and raised among its voices, Meehan makes a powerful and poignant statement of presence in her poems that contrasts with Boland's self-aware absences and retrospects. But what the conversation between the two poets reveals is not so much contrast as common purpose. Each poet has brought a powerful language to the place she lives in. While they write about the city in very different ways, Boland and Meehan are alike in that they have imagined a city. That process and commitment is what this book, through text, image and conversation, seeks to unfold.

Jody Allen Randolph

A POET'S DUBLIN

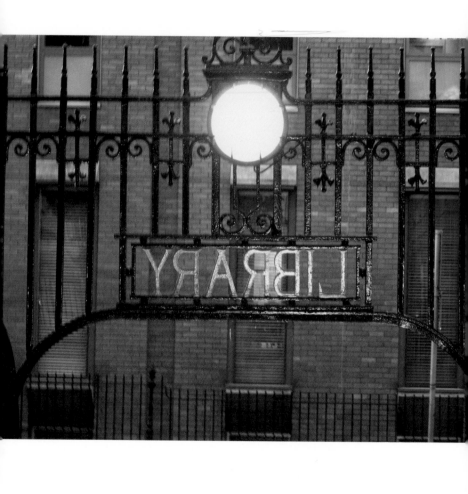

I

CITY OF SHADOWS

As dusk fell on the city, a conversational life intensified. Libraries filled up; the green-cowled lamps went on and light pooled onto open pages. The pubs were crowded. The cafés were full of students and apprentice writers like myself, some of them talking about literature, a very few talking intensely about poetry.

Only a few miles away was the almost invisible world that everyone knew of and no one referred to. Of suburbs and housing estates. Of children and women. Of fires lighted for the first winter chill; of food put on the table. No one referred to this. The so-called ordinary world, which most of us had come from and some would return to on the last bus, was not even mentioned. Young poets are like children. They assume the dangers to themselves are those their elders identified; they internalise the menace without analysing it. It was not said, it was not even consciously thought and yet I absorbed the sense that poetry was safe here in this city at twilight, with its violet sky and constant drizzle, within this circle of libraries and pubs and talks about stanzas and cadences. Beyond it was the ordinariness which could only dissipate it; beyond it was a life for which no visionary claim could be made.

ATLANTIS — A LOST SONNET

How on earth did it happen, I used to wonder
that a whole city – arches, pillars, colonnades,
not to mention vehicles and animals – had all
one fine day gone under?

I mean, I said to myself, the world was small then.
Surely a great city must have been missed?
I miss our old city –

white pepper, white pudding, you and I meeting
under fanlights and low skies to go home in it. Maybe
what really happened is

this: the old fable-makers searched hard for a word
to convey that what is gone is gone forever and
never found it. And so, in the best traditions of

where we come from, they gave their sorrow a name
and drowned it.

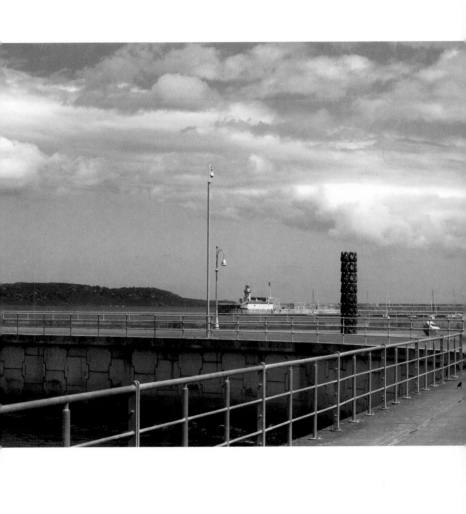

ONCE IN DUBLIN

Small things
make the past.
Make the present seem out of place.

A woman cracking and twisting.
Black atoms falling down
on green leaves.

If I am ever to go back
to what I loved first
here are words to be wished on –

(almost, you can see, an incantation).

Summon blue air
out of a corridor between
a mountain range and a sea –

(this at least has never changed).

Empty out the streets.
Fit the cars easily
into their parking places.
Slow the buses down by thirty years.

Observe a brave, fiery shower
above a plate
of bacon and potatoes –

(we are nearly there).

Now say *dinner* for *lunch*.
And *tea-time* instead of *supper.*

And see how it comes again –

My little earth.

My city of white pepper.

UNHEROIC

It was an Irish summer. It was wet.
It was a job. I was seventeen.
I set the clock and caught the bus at eight
and leaned my head against the misty window.
The city passed by. I got off
above the Liffey on a street of statues:
iron orators and granite patriots.
Arms wide. Lips apart. Last words.

I worked in a hotel. I carried trays.
I carried keys. I saw the rooms
when they were used and airless and again
when they were aired and ready and I stood
above the road and stared down at
silent eloquence and wet umbrellas.

There was a man who lived in the hotel.
He was a manager. I rarely saw him.
There was a rumour that he had a wound
from war or illness – no one seemed sure –
which would not heal. And when he finished
his day of ledgers and telephones he went
up the back stairs to his room
to dress it. I never found out
where it was. Someone said in his thigh.
Someone else said deep in his side.

He was a quiet man. He spoke softly.
I saw him once or twice on the stairs
at the back of the building by the laundry.
Once I waited, curious to see him.

Mostly I went home. I got my coat
and walked bare-headed to the river
past the wet, bronze and unbroken skin
of those who learned their time and knew their country.

How do I know my country? Let me tell you
it has been hard to do. And when I do
go back to difficult knowledge, it is not
to that street or those men raised
high above the certainties they stood on –
Ireland hero history – but how

I went behind the linen room and up
the stone stairs and climbed to the top.
And stood for a moment there, concealed
by shadows. In a hiding place.
Waiting to see.
Wanting to look again.
Into the patient face of the unhealed.

THE HUGUENOT GRAVEYARD AT THE HEART
OF THE CITY

It is the immodesty we bring to these
names which have eased into ours, and
their graves in the alcove of twilight,
which shadows their exile.

There is a flattery in being a destination.
There is a vanity in being the last resort.
They fled the Edict of Nantes –
hiding their shadows on the roads from France –

and now under brambles and granite
faith lies low with the lives it
dispossessed, and the hands it emptied out,
and the sombre dances they were joined in.

The buses turn right at Stephen's Green.
Car exhausts and sirens fill the air. See
the planted wildness of their rest and
grant to them the least love asks of

the living. Say: *they had another life once.*
And think of them as they first heard of us:
huddled around candles and words failing as
the stubborn tongue of the South put

oo and *an* to the sounds of Dublin,
and of their silver fingers at the window-sill
in the full moon as they leaned out
to breathe the sweet air of Nîmes

for the last time, and the flame
burned down in a dawn agreed upon
for their heart-broken leave-taking. And,
for their sakes accept in that moment

this city with its colours of sky and day –
and which is dear to us and particular –
was not a place to them: merely
the one witty step ahead of hate which

is all that they could keep. Or stay.

CITY OF SHADOWS

When I saw my father
buttoning his coat at Front Gate
I thought he would look like a man
who had lost what he had. And he did.

Grafton Street and Nassau Street were gone.
And the old parliament at College Green.
And the bronze arms and attitudes of orators
from Grattan to O'Connell. All gone.

We went to his car. He got in.
I waved my hands and motioned him to turn
his wheel towards the road to the only
straight route out to the coast.

When he did
I walked beside the car,
beside the curb, and we made our way
in dark inches to the Irish Sea.

Then I smelled salt
and heard the foghorn.
And realised suddenly that I
had brought my father to his destination.

I walked home
alone to my flat.
The fog was lifting slowly. I thought
whatever the dawn made clear

and cast-iron and adamant again,
I would know from now on that in
a lost land of orators and pedestals
and corners and street names and rivers,

where even the ground underfoot
was hidden from view, there had been
one way out.
And I found it.

A FALSE SPRING

Alders are tasselled.
Flag-iris is already out on the canal.

From my window I can see
the College gardens, crocuses stammering
in pools of rain, plum blossom
on the branches.

I want to find her,
the woman I once was,
who came out of that reading-room
in a hard January, after studying
Aeneas in the underworld,

how his old battle-foes spotted him there –

how they called and called and called
only to have it be
a yell of shadows, an O vanishing in
the polished waters
and the topsy-turvy seasons of hell –

her mind so frail her body was its ghost.

I want to tell her she can rest,
she is embodied now.

But narcissi,
opening too early,
are all I find.
I hear the bad sound of these south winds,
the rain coming from some region which has lost sight
of our futures, leaving us
nothing to look forward to except
what one serious frost can accomplish.

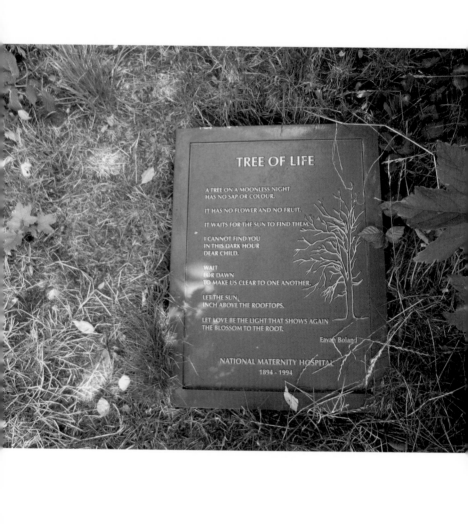

TREE OF LIFE

A TREE ON A MOONLESS NIGHT
HAS NO SAP OR COLOUR.

IT HAS NO FLOWER AND NO FRUIT.

IT WAITS FOR THE SUN TO FIND THEM.

I CANNOT FIND YOU
IN THIS DARK HOUR
DEAR CHILD.

WAIT
FOR DAWN
TO MAKE US CLEAR TO ONE ANOTHER.

LET THE SUN,
INCH ABOVE THE ROOFTOPS.

LET LOVE BE THE LIGHT THAT SHOWS AGAIN
THE BLOSSOM TO THE ROOT.

Eavan Boland

NATIONAL MATERNITY HOSPITAL
1894 - 1994

TREE OF LIFE

A tree on a moonless night
has no sap or colour.

It has no flower and no fruit.

It waits for the sun to find them.

I cannot find you
in this dark hour
dear child.

Wait
for dawn to make us clear to one another.

Let the sun
inch above the roof-tops,

Let love
be the light that shows again

the blossom to the root.

Commissioned by the National Maternity Hospital, Dublin, during its
1994 Centenary, to mark a service to commemorate the babies who had
died there.

NATIONHOOD: TWO FAILED SONNETS

Speranza –
on a winter evening
loosening her hair,
looking for the paper left
by the window: words
crossed out, words
to write down before supper.

January rinses
Merrion Square with grime, lets
the colliers stamp in late with
wet coats and coal, lets
the carriages finish up
their business of calling
and colony.

A dewy silence
of *Pax Britannica,*
its stewards sleeping
through a peace that
will never hold.
She is up late.

On the edge, at the brink
Above an underworld.
My country wounded to the heart.
We should go now. She is
busy with
the transformation.
She is writing to Ireland.
Ireland. She is.

THE DOLLS MUSEUM IN DUBLIN

The wounds are terrible. The paint is old.
The cracks along the lips and on the cheeks
cannot be fixed. The cotton lawn is soiled.
The arms are ivory dissolved to wax.

Recall the quadrille. Hum the waltz.
Promenade on the yacht-club terraces.
Put back the lamps in their copper holders,
the carriage wheels on the cobbled quays.

And recreate Easter in Dublin.
Booted officers. Their mistresses.
Sunlight criss-crossing College Green.
Steam hissing from the flanks of horses.

Here they are. Cradled and cleaned,
held close in the arms of their owners.
Their cold hands clasped by warm hands,
their faces memorised like perfect manners.

The altars are mannerly with linen.
The lilies are whiter than surplices.
The candles are burning and warning:
Rejoice, they whisper. After sacrifice.

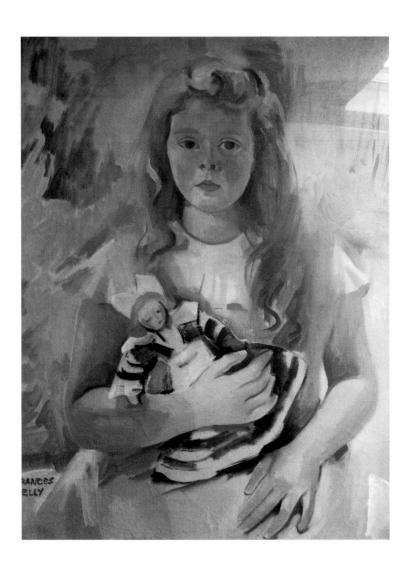

Horse chestnuts hold up their candles.
The Green is vivid with parasols.
Sunlight is pastel and windless.
The bar of the Shelbourne is full.

Laughter and gossip on the terraces.
Rumour and alarm at the barracks.
The Empire is summoning its officers.
The carriages are turning: they are turning back.

Past children walking with governesses,
looking down, cossetting their dolls,
then looking up as the carriage passes,
the shadow chilling them. Twilight falls.

It is twilight in the dolls museum. Shadows
remain on the parchment-coloured waists,
are bruises on the stitched cotton clothes,
are hidden in the dimples on the wrists.

The eyes are wide. They cannot address
the helplessness which has lingered in
the airless peace of each glass case:
to have survived. To have been stronger than

a moment. To be the hostages ignorance
takes from time and ornament from destiny. Both.
To be the present of the past. To infer the difference
with a terrible stare. But not feel it. And not know it.

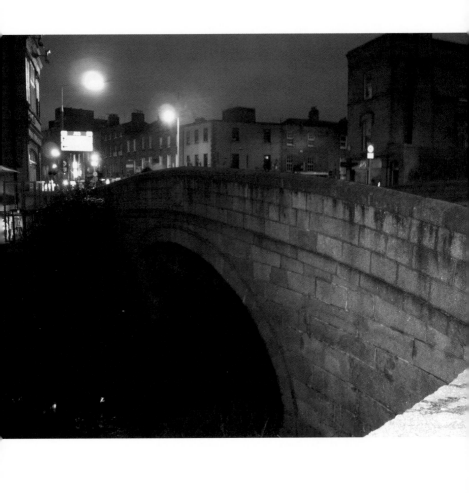

AN ELEGY FOR MY MOTHER IN WHICH
SHE SCARCELY APPEARS

I knew we had to grieve for the animals
a long time ago: weep for them, pity them.
I knew it was our strange human duty
to write their elegies after we arranged their demise.
I was young then and able for the paradox.
I am older now and ready with the question:
What happened to them all? I mean to those
old dumb implements which have
no eyes to plead with us like theirs,
no claim to make on us like theirs? I mean –

there was a singing kettle. I want to know
why no one tagged its neck or ringed the tin
base of its extinct design or crouched to hear
its rising shriek in winter or wrote it down with
the birds in their blue sleeves of air
torn away with the trees that sheltered them.

And there were brass fire dogs which lay out
all evening on the grate and in the heat
thrown at them by the last of the peat fire
but no one noted down their history or put them
in the old packs under slate-blue moonlight.
There was a wooden clothes horse, absolutely steady
without sinews, with no mane and no meadows
to canter in; carrying, instead of
landlords or Irish monks, rinsed tea cloths
but still, I would have thought, worth adding to
the catalogue of what we need, what we always need

as is my mother, on this Dublin evening of
fog crystals and frost as she reaches out to test
one corner of a cloth for dryness as the prewar
Irish twilight closes in and down on the room
and the curtains are drawn and here am I,
not even born and already a conservationist,
with nothing to assist me but the last
and most fabulous of beasts – language, language –
which knows, as I do, that it's too late
to record the loss of these things but does so anyway,
and anxiously, in case it shares their fate.

WE WERE NEUTRAL IN THE WAR

This warm, late summer there is so much
to get in. The ladder waits by the crab apple tree.
The greenhouse is rank with the best
Irish tomatoes. Pears are ripening.

Your husband frowns at dinner, has no time
for the baby who has learned to crease three
fingers and wave 'day-day'. This is serious,
he says. This could be what we all feared.

You pierce a sequin with a needle.
You slide it down single-knotted thread
until it lies with all the others in
a puzzle of brightness. Then another and another one.

Let the green and amber marrows rise up
and beat against it and the crab apples and
the damson-coloured pram by the back
wall: you will not sew them into it.

The wooden ledge of the conservatory
faces south. Row on row,
the pears are laid out there, are hard
and then yellow and then yellow with

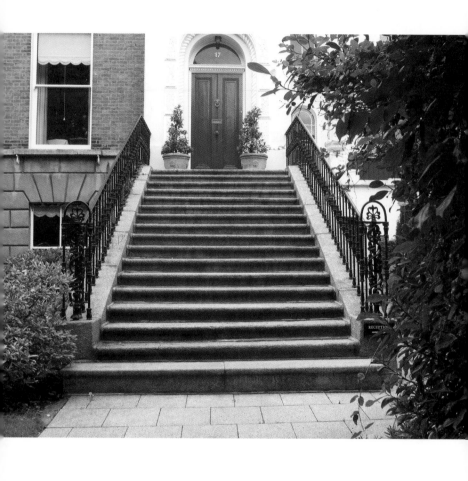

a rosiness. You leave them out of it.
They will grow soft and bruised at the top
and rot, all in one afternoon. The light,
which made them startling, you will use.

On the breakfast table the headlines are
telling of a city under threat where
you mixed cheese with bitter fennel and
fell in love over demitasse. Afterwards,

you walked by the moonlit river and stopped
and looked down. A glamorous circumference is
spinning on your needle, is
that moon in satin water making

the same peremptory demands on
the waves of the Irish Sea and as each
salt-window opens to reveal
a weather of agates, you will stitch that in

with the orchard colours of the first preserves
you make from the garden. You move the jars from
the pantry to the window-sill where
you can see them: winter jewels.

The night he comes to tell you this is war
you wait for him to put on his dinner jacket.
The party is tonight.
The streets are quiet. Dublin is at peace.

The talk is of death but you take
the hand of the first man who asks you.
You dance the fox-trot, the two-step,
the quick-step,

in time to the music. Exclusions
glitter at your hips and past and future are
the fended-off and far-fetched
in waltz time below your waist.

HEROIC

Sex and history. And skin and bone.
And the oppression of Sunday afternoon.
Bells called the faithful to devotion.

I was still at school and on my own.
And walked and walked and sheltered from the rain.

The patriot was made of drenched stone.
His lips were still speaking. The gun
he held had just killed someone.

I looked up. And looked at him again.
He stared past me without recognition.

I moved my lips and wondered how the rain
would taste if my tongue were made of stone.
And wished it was. And whispered so that no one
could hear it but him. *Make me a heroine.*

IN MEMORY OF
THE VICTIMS WHO
DIED IN DUBLIN
AND MONAGHAN
BOMBINGS 1974

CHRISTINA O'LOUGHLIN
EDWARD O'NEILL
MARIE PHELAN
SIOBHAN ROICE
MAUREEN SHIELDS
BREDA TURNER
JOSEPHINE BRADLEY
ELIZABETH FITZGERALD
ARCHIE HARPER
PEGGY WHITE
JACK TRAVERS
THOMAS CAMPBELL
GEORGE WILLIAMSON
PATRICK ASKIN
COLETTE DOHERTY
THOMAS CROARKIN
BABY DOHERTY

CHILD OF OUR TIME

for Aengus

Yesterday I knew no lullaby
But you have taught me overnight to order
This song, which takes from your final cry
Its tune, from your unreasoned end its reason,
Its rhythm from the discord of your murder
Its motive from the fact you cannot listen.

We who should have known how to instruct
With rhymes for your waking, rhythms for your sleep,
Names for the animals you took to bed,
Tales to distract, legends to protect,
Later an idiom for you to keep
And living, learn, must learn from you, dead,

To make our broken images rebuild
Themselves around your limbs, your broken
Image, find for your sake whose life our idle
Talk has cost, a new language. Child
Of our time, our times have robbed your cradle.
Sleep in a world your final sleep has woken.

17 May 1974

CANALETTO IN THE NATIONAL GALLERY
OF IRELAND

Something beating in
making pain and attention –
a heat still
livid on the skin
is the might-have-been:

the nation, the city
which fell
for want of
the elevation in
this view of the Piazza,

its everyday light
making it everyone's
remembered city:
airs and shadows,
cambered distances.

I remember
a city like this –
the static coral
of reflected brick
in its river.

I envy these
pin-pointed citizens
their solid ease,
their lack of any need
to come and see

the beloved republic
raised
and saved
and scalded into
something measurable.

II

GIFTS OF THE RIVER

I begin with the Liffey because a river is not a place: it is a maker of places. Without the river there would be no city. Every day, turning its narrow circle, endlessly absorbing and re-absorbing the shapes and reflections of the city, it mirrors what it created. With the river, the city every day has to throw itself again into those surfaces, those depths, those reflections which have served as the source of all its fictions.

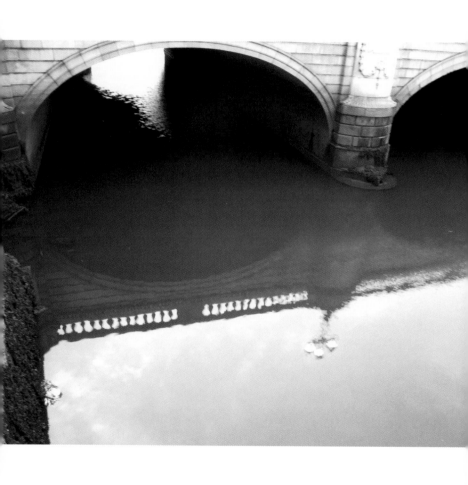

THE SCAR

Dawn on the river.
Dublin rises out of what reflects it.

Anna Liffey
looks to the east, to the sea,
her profile carved out by the light
on the old Carlisle bridge.

I was five
when a piece of glass
cut my head and left a scar.
Afterwards my skin felt different.

And still does on these autumn days when
the mist hides the city
from the Liffey.

The Liffey hides
the long ships, the muskets and the burning domes.

Everything but this momentary place.
And those versions of the Irish rain
which change the features
of a granite face.

If colony is a wound what will heal it?
After such injuries
what difference do we feel?

No answer in the air,
on the water, in the distance.
And yet

Emblem of this old,
torn and traded city,
altered by its river, its weather,
I turn to you as if there were.

One flawed head towards another.

ANNA LIFFEY

Life, the story goes,
Was the daughter of Cannan,
And came to the plain of Kildare.
She loved the flat-lands and the ditches
And the unreachable horizon.
She asked that it be named for her.
The river took its name from the land.
The land took its name from a woman.

A woman in the doorway of a house.
A river in the city of her birth.

There, in the hills above my house,
The river Liffey rises, is a source.
It rises in rush and ling heather and
Black peat and bracken and strengthens
To claim the city it narrated.
Swans. Steep falls. Small towns.
The smudged air and bridges of Dublin.

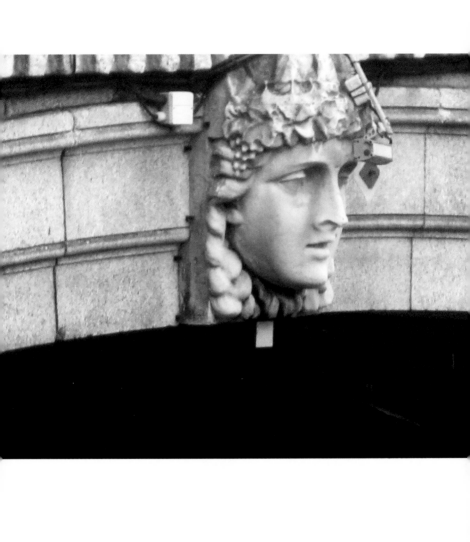

Dusk is coming.
Rain is moving east from the hills.

If I could see myself
I would see
A woman in a doorway
Wearing the colours that go with red hair.
Although my hair is no longer red.

I praise
The gifts of the river.
Its shiftless and glittering
Re-telling of a city,
Its clarity as it flows,
In the company of runt flowers and herons,
Around a bend at Islandbridge
And under thirteen bridges to the sea.
Its patience at twilight –
Swans nesting by it,
Neon wincing into it.

Maker of
Places, remembrances,
Narrate such fragments for me:

One body. One spirit.
One place. One name.
The city where I was born.
The river that runs through it.
The nation which eludes me.

Fractions of a life
It has taken me a lifetime
To claim.

I came here in a cold winter.
I had no children. No country.
I did not know the name for my own life.

My country took hold of me.
My children were born.

I walked out in a summer dusk
To call them in.

One name. Then the other one.
The beautiful vowels sounding out home.

Make of a nation what you will
Make of the past
What you can –

There is now
A woman in a doorway.

It has taken me
All my strength to do this.

Becoming a figure in a poem.

Usurping a name and a theme.

A river is not a woman.
 Although the names it finds,
 The history it makes
And suffers –
 The Viking blades beside it,
 The muskets of the Redcoats,
 The flames of the Four Courts
Blazing into it
 Are a sign.
 Any more than
A woman is a river,
 Although the course it takes,
 Through swans courting and distraught willows,

Its patience
 Which is also its powerlessness,
 From Callary to Islandbridge,
 And from source to mouth,
Is another one.
 And in my late forties
Past believing
 Love will heal
 What language fails to know
And needs to say –
 What the body means –
 I take this sign
And I make this mark:
 A woman in the doorway of her house.
 A river in the city of her birth.
The truth of a suffered life.
 The mouth of it.

The seabirds come in from the coast.
The city wisdom is they bring rain.
I watch them from my doorway.
I see them as arguments of origin –
Leaving a harsh force on the horizon
Only to find it
Slanting and falling elsewhere.

Which water –
The one they leave or the one they pronounce –
Remembers the other?

I am sure
The body of an ageing woman
Is a memory
And to find a language for it
Is as hard
As weeping and requiring
These birds to cry out as if they could
Recognise their element
Remembered and diminished in
A single tear.

An ageing woman
Finds no shelter in language.
She finds instead
Single words she once loved
Such as 'summer' and 'yellow'
And 'sexual' and 'ready'
Have suddenly become dwellings
For someone else –
Rooms and a roof under which someone else
Is welcome, not her. Tell me,
Anna Liffey,

Spirit of water,
Spirit of place,
How is it on this
Rainy autumn night
As the Irish Sea takes
The names you made, the names
You bestowed, and gives you back
Only wordlessness?

Autumn rain is
Scattering and dripping
From car-ports
And clipped hedges.
The gutters are full.

When I came here
I had neither
Children nor country.
The trees were arms.
The hills were dreams.

I was free
To imagine a spirit
In the blues and greens,
The hills and fogs
Of a small city.

My children were born.
My country took hold of me.
A vision in a brick house.
Is it only love
That makes a place?

I feel it change.
My children are
Growing up, getting older.
My country holds on
To its own pain.

I turn off
The harsh yellow
Porch light and
Stand in the hall.
Where is home now?

Follow the rain
Out to the Dublin hills.
Let it become the river.
Let the spirit of place be
A lost soul again.

In the end
It will not matter
That I was a woman. I am sure of it.
The body is a source. Nothing more.
There is a time for it. There is a certainty
About the way it seeks its own dissolution.
Consider rivers.
They are always en route to
Their own nothingness. From the first moment
They are going home. And so
When language cannot do it for us,
Cannot make us know love will not diminish us,
There are these phrases
Of the ocean
To console us.
Particular and unafraid of their completion.
In the end
Everything that burdened and distinguished me
Will be lost in this:
I was a voice.

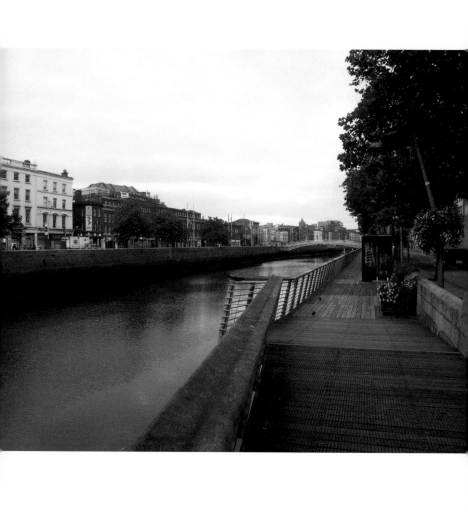

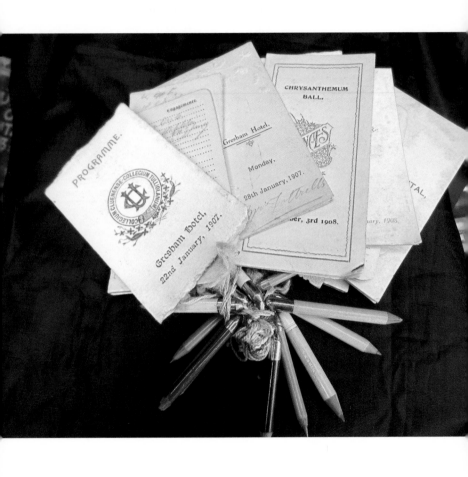

HOW THE DANCE CAME TO THE CITY

It came with the osprey, the cormorants, the air
at the edge of the storm, on the same route as
the blight and with the nightly sweats that said *fever*.

It came with the scarlet tunics and rowel-spurs,
with the epaulettes and their poisonous drizzle of gold,
with the boots, the gloves, the whips, the flash of the cuirasses.

It came with a sail riding the empire-blue haze
of the horizon growing closer, gaining and then
it was there: the whole creaking orchestra of salt and canvas.

And here is the cargo, deep in the hold of the ship,
stored with the coiled ropes and crated spice and coal,
the lumber and boredom of arrival, underneath

timbers shifting and clicking from the turnaround
of the tides locked at the mouth of Dublin Bay, is
the two-step, the quick-step, the whirl, the slow return.

Tonight in rooms where skirts appear steeped in tea
when they are only deep in shadow and where heat
collects at the waist, the wrist, is wet at the base of the neck,

the secrets of the dark will be the truths of the body
a young girl feels and hides even from herself as she lets fall
satin from her thighs to her ankles, as she lets herself think

how it started, just where: with the minuet, the quadrille,
the chandeliers glinting, the noise wild silk makes and
her face flushed and wide-eyed in the mirror of his sword.

THE HARBOUR

This harbour was made by art and force.
And called Kingstown and afterwards Dun Laoghaire.
And holds the sea behind its barrier
less than five miles from my house.

Lord be with us say the makers of a nation.
Lord look down say the builders of a harbour.
They came and cut a shape out of ocean
and left stone to close around their labour.

Officers and their wives promenaded
on this spot once and saw with their own eyes
the opulent horizon and obedient skies
which nine-tenths of the law provided.

And frigates with thirty-six guns cruising
the outer edges of influence could idle
and enter here and catch the tide of
empire and arrogance and the Irish Sea rising

and rising through a century of storms
and cormorants and moonlight the whole length of this coast,
while an ocean forgot an empire and the armed
ships under it changed: to slime weed and cold salt and rust.

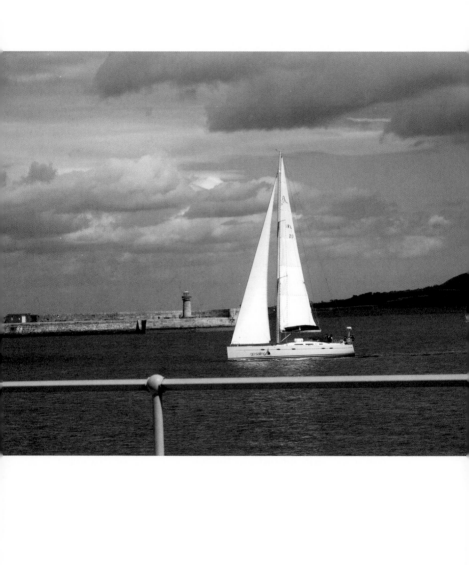

City of shadows and of the gradual
capitulations to the last invader
this is the final one: signed in water
and witnessed in granite and ugly bronze and gun-metal.

And by me. I am your citizen: composed of
your fictions, your compromise, I am
a part of your story and its outcome.
And ready to record its contradictions.

DUN LAOGHAIRE
HARBOUR

The Dun Laoghaire Harbour Company
is pleased to acknowledge that
the development of this Marina Promenade
has been assisted by

THE LONG EVENINGS OF THEIR LEAVE-TAKINGS

My mother was married by the water.
She wore a grey coat and a winter rose.

She said her vows beside a cold seam of the Irish coast.

She said her vows near the shore where
the emigrants set down their consonantal *n:*

on after*n*oo*n*, on the e*n*d of everything, at the start of *ever.*

Yellow vestments took in light
a chalice hid underneath its veil.

Her hands were full of calla and cold weather lilies.

The mail packet dropped anchor.
A black-headed gull swerved across the harbour.

Icy promises rose beside a cross-hatch of ocean and horizon.

I am waiting for the words of the service. I am waiting for
keep thee only and *all my earthly.*

All I hear is an afternoon's worth of *never.*

AND SOUL

My mother died one summer –
the wettest in the records of the state.
Crops rotted in the west.
Checked tablecloths dissolved in back gardens.
Empty deckchairs collected rain.
As I took my way to her
through traffic, through lilacs dripping blackly
behind houses
and on curbsides, to pay her
the last tribute of a daughter,
I thought of something I remembered
I heard once, that the body is, or is
said to be, almost all
water and as I turned southward, that ours is
a city of it,
one in which
every single day the elements begin
a journey towards each other that will never,
given our weather,
fail –
 the ocean visible in the edges cut by it,
cloud colour reaching into air,
the Liffey storing one and summoning the other,
salt greeting the lack of it at the North Wall and,
as if that wasn't enough, all of it
ending up almost every evening
inside our speech –

coast canal ocean river stream and now
mother and I drove on and although
the mind is unreliable in grief, at
the next cloudburst, it almost seemed
they could be shades of each other,
the way the body is
of every one of them and now
they were on the move again – fog into mist,
mist into sea spray and both into the oily glaze
that lay on the railings of
the house she was dying in
as I went inside.

THE PROOF THAT PLATO WAS WRONG

August. And already
 light is assembling
another season at
 the end of an avenue
of water every tree is
 getting ready to
shed its leaves under.
 I was young here.
I am older here.
 I have come here
to find courage in
 the way this dawn
reaches slowly down
 the canal and reveals
a drowned summer
 which is almost over.
In the submarine
 greenness of these trees

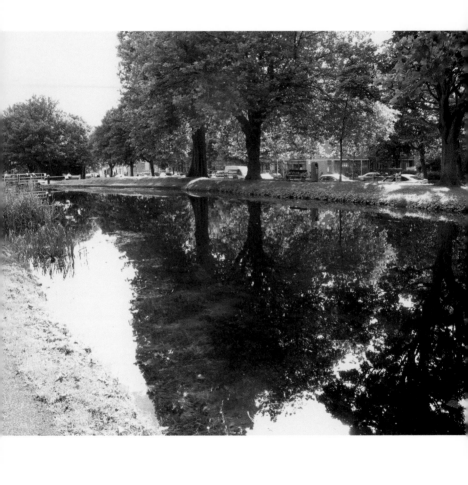

whose roots and sinews
 are only – after all –
rain. And in these birds
 which cannot be heard,
which will never be
 heard. But are still
beginning to
 raise their heads
and open out
 their flooded wings,
as if they had not
 forgotten what
song is.

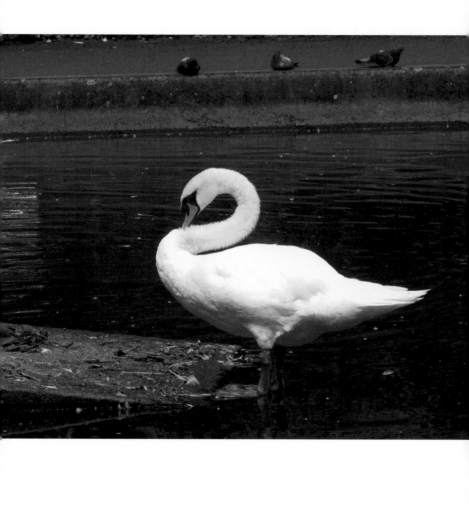

ESCAPE

I

It was only when a swan
made her nest
on the verge beside Leeson Street bridge,

and too near the curb by the canal,
that I remembered
my first attempt at an Irish legend.

And stopped the car
and walked over to her.
And into my twentieth winter:

II

The window open where I left it.
The table cloth still on the table.
The page at the last line I crafted.

III

I sat in the kitchen and frost
blended with kettle steam while
I crossed out and crossed out
the warm skin and huggable limbs
of Lir's children –
rhyming them into doomed swans

cursed into flight on
a coast that was only half a mile
from my flat in Morehampton Road.

IV

It was evening now. Overhead
wild stars had wheels and landing gear.

A small air of spring hung above
the verge with its bottle lids and papers,
its poplar shadows,
its opening narcissi
and passers-by hurrying home from offices,
who barely turned to see what was there:

V

A mother bird too near the road.

A middle-aged woman going
as near to her as she dared.

Neither of them willing
to stir from the actual and ordinary
momentary danger.

One of them aware of the story.

Both of them escaped from the telling.

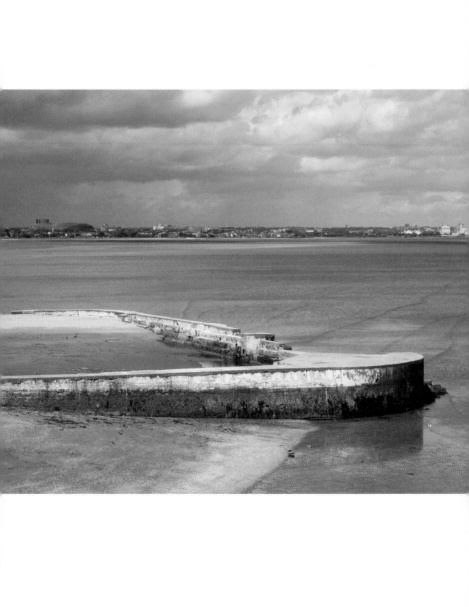

CITYSCAPE

I have a word for it –
the way the surface waited all day
to be a silvery pause between sky and city –
which is *elver*.

And another one for how
the bay shelved cirrus clouds
piled up at the edge of the Irish Sea,
which is *elver* too.

The old Blackrock baths
have been neglected now for fifty years,
fine cracks in the tiles
visible as they never were when

I can I can I can
shouted Harry Vernon as
he dived from the highest board
curving down into salt and urine

his cry fading out
through the half century it took me
to hear as a child that a glass eel
had been seen

entering the sea-water baths at twilight –
also known as *elver* –
and immediately
the word begins

a delicate migration –
a fine crazing healing in the tiles –
the sky deepening above a city
that has always been

unsettled between sluice gates and the Irish Sea
to which there now comes at dusk
a translucent visitor
yearning for the estuary.

III

UNDER THESE HILLS

Dundrum is an Anglicisation of a Gaelic place name meaning 'the Fort on the Ridge'. In the eleventh century it became, like so many other Dublin townlands, part of the Norman fortifications of the city. The castles which were built – and Dundrum had one of them – stood as a line of defence against the raids of the Wicklow clans who marauded in at night to attack the new invaders. By the nineteenth century, the small Norman township had become a sober village. It appears briefly in advertisements in 1820 promoting the excellence of goat's milk and styling itself as a spa resort offering a rest cure near the mountains. In 1813 a morning newspaper carried the notice for Meadowbrook House, on a street just around the corner from the house we would buy: 'The second whey season having commenced, Ladies and Gentlemen are respectively informed that there are a few vacancies in the house'. By the end of the nineteenth century the village was acquiring other things as well – putting on the darkness as well as the light of that prosperous century. Behind the main street was a private asylum – a large house hidden by leafy trees. Elsewhere, life was more normal. The grocery shops sold smoked bacon and homemade butter. Two small tributaries, the Swan and the

Tinnehy, flowed together at the edge of the village and with enough force to power a paper mill which made bank notes. Mill cottages were set down at the edges of the water. More importantly, above the shops, asylums, houses and cottages ran the Harcourt Street Line, a train service that was gone by the time we got there. Until the 1950s, Dundrum must have continued in that way – looking like so many other neighbourhoods a few miles from Dublin. A mixture, like so many others, of graceful seclusion and hard, practical daily life. A long main street. Some shops. The shadows and leaves of poplars and rowans and mulberries shielding it from any appearance of busyness or stress. A quiet, forgotten neighbourhood. But already a noise was beginning, just out of earshot. The noise of a new Ireland.

THE WAR HORSE

This dry night, nothing unusual
About the clip, clop, casual

Iron of his shoes as he stamps death
Like a mint on the innocent coinage of earth.

I lift the window, watch the ambling feather
Of hock and fetlock, loosed from its daily tether

In the tinker camp on the Enniskerry Road
Pass, his breath hissing, his snuffling head

Down. He is gone. No great harm is done.
Only a leaf of our laurel hedge is torn –

Of distant interest like a maimed limb,
Only a rose which now will never climb

The stone of our house, expendable, a mere
Line of defence against him, a volunteer

You might say, only a crocus its bulbous head
Blown from growth, one of the screamless dead.

But we, we are safe, our unformed fear
Of fierce commitment gone; why should we care

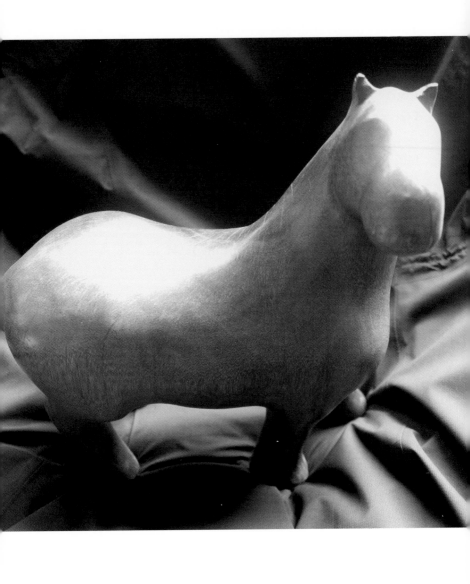

If a rose, a hedge, a crocus are uprooted
Like corpses, remote, crushed, mutilated?

He stumbles on like a rumour of war, huge,
Threatening; neighbours use the subterfuge

Of curtains; he stumbles down our short street
Thankfully passing us. I pause, wait,

Then to breathe relief lean on the sill
And for a second only my blood is still

With atavism. That rose he smashed frays
Ribboned across our hedge, recalling days

Of burned countryside, illicit braid:
A cause ruined before, a world betrayed.

THIS MOMENT

A neighbourhood.
At dusk.

Things are getting ready
to happen
out of sight.

Stars and moths.
And rinds slanting around fruit.

But not yet.

One tree is black.
One window is yellow as butter.

A woman leans down to catch a child
who has run into her arms
this moment.

Stars rise.
Moths flutter.
Apples sweeten in the dark.

NIGHT FEED

This is dawn.
Believe me
This is your season, little daughter.
The moment daisies open,
The hour mercurial rainwater
Makes a mirror for sparrows.
It's time we drowned our sorrows.

I tiptoe in.
I lift you up
Wriggling
In your rosy,
zipped sleeper.
Yes, this is the hour
For the early bird and me
When finder is keeper.

I crook the bottle.
How you suckle!
This is the best I can be,
Housewife
To this nursery
Where you hold on,
Dear life.

A silt of milk.
The last suck.
And now your eyes are open,
Birth-coloured and offended.
Earth wakes.
You go back to sleep.
The feed is ended.

Worms turn.
Stars go in.
Even the moon is losing face.
Poplars stilt for dawn
And we begin
The long fall from grace.
I tuck you in.

THE POMEGRANATE

The only legend I have ever loved is
the story of a daughter lost in hell.
And found and rescued there.
Love and blackmail are the gist of it.
Ceres and Persephone the names.
And the best thing about the legend is
I can enter it anywhere. And have.
As a child in exile in
a city of fogs and strange consonants,
I read it first and at first I was
an exiled child in the crackling dusk of
the underworld, the stars blighted.
Later I walked out in a summer twilight
searching for my daughter at bed-time.
When she came running I was ready
to make any bargain to keep her.
I carried her back past whitebeams
and wasps and honey-scented buddleias.
But I was Ceres then and I knew
winter was in store for every leaf
on every tree on that road.
Was inescapable for each one we passed.
And for me.
 It is winter
and the stars are hidden.
I climb the stairs and stand where I can see
my child asleep beside her teen magazines,

her can of Coke, her plate of uncut fruit.
The pomegranate! How did I forget it?
She could have come home and been safe
and ended the story and all
our heart-broken searching but she reached
out a hand and plucked a pomegranate.
She put out her hand and pulled down
the French sound for apple and
the noise of stone and the proof
that even in the place of death,
at the heart of legend, in the midst
of rocks full of unshed tears
ready to be diamonds by the time
the story was told, a child can be
hungry. I could warn her. There is still a chance.
The rain is cold. The road is flint-coloured.
The suburb has cars and cable television.
The veiled stars are above ground.
It is another world. But what else
can a mother give her daughter but such
beautiful rifts in time?
If I defer the grief I will diminish the gift.
The legend will be hers as well as mine.
She will enter it. As I have.
She will wake up. She will hold
the papery flushed skin in her hand.
And to her lips. I will say nothing.

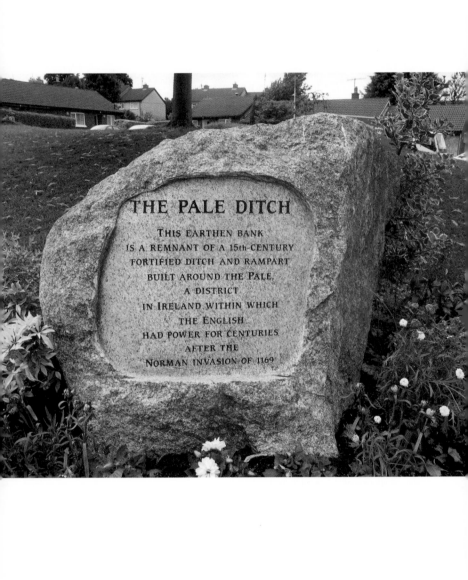

THE PALE DITCH

THIS EARTHEN BANK
IS A REMNANT OF A 15th-CENTURY
FORTIFIED DITCH AND RAMPART
BUILT AROUND THE PALE,
A DISTRICT
IN IRELAND WITHIN WHICH
THE ENGLISH
HAD POWER FOR CENTURIES
AFTER THE
NORMAN INVASION OF 1169

THE MOTHER TONGUE

The old pale ditch can still be seen
less than half a mile from my house –

its ancient barrier of mud and brambles
which mireth next unto Irishmen
is now a mere rise of coarse grass,
a rowan tree and some thinned-out spruce,
where a child is playing at twilight.

I stand in the shadows. I find it
hard to believe now that once
this was a source of our division:

Dug. Drained. Shored up and left
to keep out and keep in. That here
the essence of a colony's defence
was the substance of the quarrel with its purpose:

Land. Ground. A line drawn in rain
and clay and the roots of wild broom –
behind it the makings of a city,
beyond it the rumours of a nation –

by Dalkey and Kilternan and Balally
through two ways of saying their names.

A window is suddenly yellow.
A woman is calling a child.
She turns from her play and runs to her name.

Who came here under cover of darkness
from Glenmalure and the Wicklow hills
to the limits of this boundary? Who whispered
the old names for love to this earth
and anger and ownership as it opened
the abyss of their future at their feet?

I was born on this side of the Pale.
I speak with the forked tongue of colony.
But I stand in the first dark and frost
of a winter night in Dublin and imagine

my pure sound, my undivided speech
travelling to the edge of this silence.
As if to find me. And I listen: I hear
what I am safe from. What I have lost.

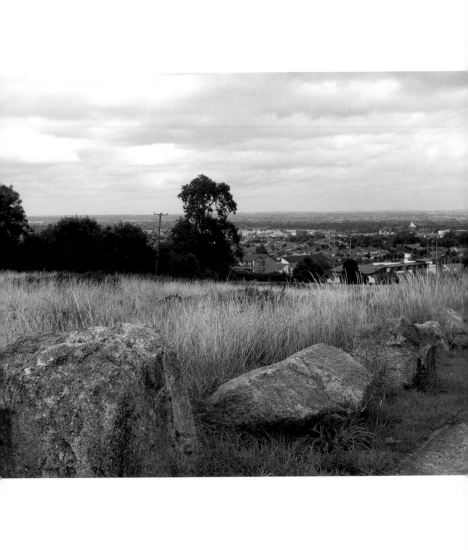

WITNESS

Here is the city –
its worn-down mountains,
its grass and iron,
its smoky coast
seen from the high roads
on the Wicklow side.

From Dalkey Island
to the North Wall,
to the blue distance seizing its perimeter,
its old divisions are deep within it.

And in me also.
And always will be:

Out of my mouth they come.
The spurred and booted garrisons.
The men and women
they dispossessed.

What is a colony
if not the brutal truth
that when we speak
the graves open.
And the dead walk?

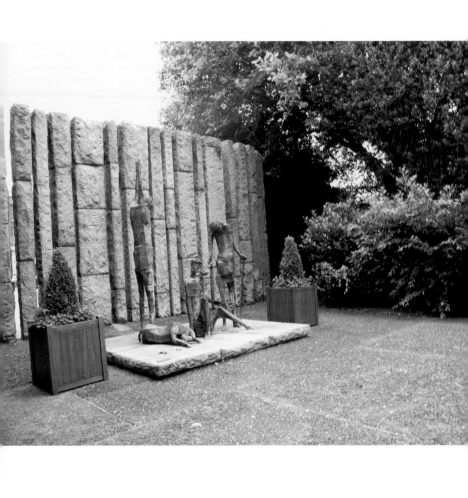

IN OUR OWN COUNTRY

They are making a new Ireland
at the end of our road,
under our very eyes,
under the arc lamps they aim and beam

into distances where we once lived
into vistas we will never recognise.

We are here to watch.
We are looking for new knowledge.

They have been working here in all weathers
tearing away the road to our village –
bridge, path, river, all
lost under an onslaught of steel.

An old Europe
has come to us as a stranger in our city,
has forgotten its own music, wars and treaties,
is now a machine from the Netherlands or Belgium

dragging, tossing, breaking apart the clay
in which our timid spring used to arrive
with our daffodils in a single, crooked row.

Remember the emigrant boat?
Remember the lost faces burned in the last glances?
The air clearing away to nothing, nothing, nothing.

We pull our collars tightly round our necks
but the wind finds our throats,
predatory and wintry.

We walk home. What we know is this
(and this is all we know): We are now
and will always be from now on –
for all I know we have always been –

exiles in our own country.

MAKING MONEY

At the turn of the century, the paper produced there was of such high quality that it was exported for use as bank-note paper.

—'Dundrum and Its Environs'

They made money –

 maybe not the way
you think it should be done
but they did it anyway.

At the end of summer
the rains came and braided
the river Slang as it ran down and down
the Dublin mountains and into faster water
and stiller air as if a storm was coming in.
And the mill wheel turned so the mill
could make paper and the paper money.
And the cottage doors opened and the women
came out in the ugly first hour
after dawn and began

　　　　　　　　to cook the rags they put
hemp waste, cotton lint, linen, flax and fishnets
from boxes delivered every day on
the rag wagon on a rolling boil. And the steam rose
up from the open coils where a shoal slipped through
in an April dawn. And in the backwash they added
alkaline and caustic and soda ash and suddenly
they were making money.

　　　　　　　　　　A hundred years ago
this is the way they came to the plum-brown
headlong weir and the sedge drowned in it
and their faces about to be as they looked down
once quickly on

their way to the mill, to the toil
of sifting and beating and settling and fraying
the weighed-out fibres. And they see how easily
the hemp has forgotten the Irish Sea at
neap tide and how smooth the weave is now in
their hands. And they do not and they never will

see the small boundaries all this will buy
or the poisoned kingdom with its waterways
and splintered locks or the peacocks who will walk
this paper up and down in the windless gardens
of a history no one can stop happening now.
Nor the crimson and indigo features
of the prince who will stare out from

the surfaces they have made on
the ruin of a Europe
he cannot see from the surface
of a wealth he cannot keep
 if you can keep
your composure in the face of this final proof that
the past is not made out of time, out of memory,
out of irony but is also
a crime we cannot admit and will not atone
it will be dawn again in the rainy autumn of the year.
The air will be a skinful of water –
the distance between storms –
again. The wagon of rags will arrive.
The foreman will buy it. The boxes will be lowered to the path
the women are walking up
as they always did, as they always will now.
Facing the paradox. Learning to die of it.

WHAT LOVE INTENDED

I can imagine if,
I came back again,
looking through windows at

broken mirrors, pictures,
and, in the cracked upstairs,
the beds where it all began.

The suburb in the rain
this October morning,
full of food and children

and animals, will be –
when I come back again –
gone to rack and ruin.

I will be its ghost,
its revenant, discovering
again in one place

the history of my pain,
my ordeal, my grace,
unable to resist

seeing what is past,
judging what has ended
and whether, first to last,

from then to now and even
here, ruined, this
is what love intended –

finding even the yellow
jasmine in the dusk,
the smell of early dinners,

the voices of our children,
taking turns and quarrelling,
burned on the distance,

gone. And the small square
where under cropped lime
and poplar, on bicycles

and skates in the summer,
they played until dark;
propitiating time.

And even the two whitebeams
outside the house gone, with
the next-door neighbour

who used to say in April –
when one was slow to bloom –
they were a man and woman.

ONCE

The lovers in an Irish story never had good fortune.
They fled the king's anger. They lay on the forest floor.
They kissed at the edge of death.

Did you know our suburb was a forest?
Our roof was a home for thrushes.
Our front door was a wild shadow of spruce.

Our faces edged in mountain freshness,
we took our milk in where the wide-apart
prints of the wild and never-seen
creatures were set who have long since died out.

I do not want us to be immortal or unlucky.
To listen for our own death in the distance.
Take my hand. Stand by the window.

I want to show you what is hidden in
this ordinary, ageing human love is
there still and will be until

an inland coast so densely wooded
not even the ocean fog could enter it
appears in front of us and the chilled-
to-the-bone light clears and shows us

Irish wolves. A silvery man and wife.
Yellow-eyed. Edged in dateless moonlight.
They are mated for life. They are legendary. They are safe.

A MARRIAGE FOR THE MILLENNIUM

Do you believe
that Progress is a woman?
A spirit seeking for its opposite?
For a true marriage to ease her quick heartbeat?

I asked you this
as you sat with your glass of red wine
and your newspaper of yesterday's events.
You were drinking and reading, and did not hear me.

Then I closed the door
and left the house behind me and began
driving the whole distance of our marriage,
away from the suburb towards the city.

One by one
the glowing windows went out.
Television screens cooled down more slowly.
Ceramic turned to glass, circuits to transistors.

Old rowans were saplings.
Roads were no longer wide.
Children disappeared from their beds.
Wives, without warning, suddenly became children.

Computer games became codes again.
The codes were folded
back into the futures of their makers.
Their makers woke from sleep, weeping for milk.

When I came to the street we once lived on
with its iron edges out of another century
I stayed there only a few minutes.
Then I was in the car, driving again.

I was ready to tell you when I got home
that high above that street in a room
above the laid-out hedges and wild lilac
nothing had changed

them, nothing ever would.
The man with his creased copy of the newspaper.
Or the young woman talking to him. Talking to him.
Her heart eased by this.

RE-READING OLIVER GOLDSMITH'S 'DESERTED VILLAGE' IN A CHANGED IRELAND

1

Well not for years – at least not then or then. I never looked at it.
 Never took it down.
The place was changing. That much was plain:
Land was sold. The little river was paved over with stone.
Lilac ran wild.
Our neighbours opposite put out the *For Sale* sign.

2

All the while, I let Goldsmith's old lament remain
Where it was: high on my shelves, stacked there at the back –
Dust collecting on its out-of-date, other-century, superannuated
 pain.

3

I come from an old country.
Someone said it was past its best. It had missed its time.
But it was beautiful. Blue suggested it, and green defined it.
Everywhere I looked it provided mirrors, mirror flashes, sounds.
Its name was not *Ireland*. It was *Rhyme*.

4

I return there for a moment as the days
Wind back, staying long enough to hear vowels rise
Around the name of a place.
Goldsmith's origin but not his source.
Lissoy. Signal and sibilance of a river-hamlet with trees.

5

And stay another moment to summon his face,
To see his pen work the surface,
To watch lampblack inks laying phrase after phrase
On the island, the village he is taking every possible care to erase.

6

And then I leave.

7

Here in our village of Dundrum
The Manor Laundry was once the Corn Mill.
The laundry was shut and became a bowling alley.
The main street held the Petty Sessions and Dispensary.

8

A spring morning.
A first gleam of sunshine in Mulvey's builder's yard.
The husbands and wives in the walled graveyard
Who brought peace to one another's bodies are not separated.
But wait. Mulvey's hardware closed down years ago.
The cemetery can't be seen from the road.

9

Now visitors come from the new Town Centre,
Built on the site of an old mill,
Their arms weighed down with brand names, fashion labels, bags.

10

Hard to know which variant
Of our country this is. Hard to say
Which variant of sound to use at the end of this line.

11

We were strangers here once. Now
Someone else
Is living out their first springtime under these hills.
Someone else
Feels the sudden ease that comes when the wind veers
South and warms rain.
Would any of it come back to us if we gave it another name?
(Sweet Auburn loveliest village of the Plain.)

12

In a spring dusk I walk to the Town Centre,
I stand listening to a small river,
Closed in and weeping.
Everyone leaving in the dusk with a single bag,
The way souls are said to enter the underworld
With one belonging.
And no one remembering.

13

A subject people knows this.
The first loss is through history.
The final one is through language.

14

It is time to go back to where I came from.

15

I take down the book. Centuries and years
Fall softly from the page. Sycamores, monasteries, a schoolhouse
And river-loving trees, their leaves casting iron-coloured shadows,
Are falling and falling
As the small town of Lissoy
Sinks deeper into sweet Augustan double talk and disappears.

TWO POETS AND A CITY
A Conversation

PAULA MEEHAN: *You have been going about Dublin with your camera these past few weeks, gathering images to accompany the poems we've chosen. The poems were written at different stages of your life, when you were mapping and negotiating a very particular Dublin; they span something like fifty years. In a way each poem is also a time capsule. So, this August you've been revisiting the places against which the life happened, and in which the life happened – that must be opening emotional channels in memory. How have you found that? What have been the erosions? What has been the most loaded photograph you've taken?*

EAVAN BOLAND: It's a good question – to look at what a camera does to and with memory. I have mixed emotions about it. Taking the photos of the city in the last few weeks has made me think about this more carefully. A camera is a heavy-handed editor. The long-ago Dublin that got into my poems is the instinctively discovered city of my late teens and early twenties. As a city, it had some peculiar features. I didn't have an Irish childhood. I was out of the country from the age of five until I was thirteen. I never found those streets as a child. I never met my friends on a certain corner. I didn't take the same bus for years at a time. So there I was walking around Stephen's Green as a student, or going back to Morehampton Road where I had a flat. There was no archive and no name-hoard to help me track what I was doing. All the same I knew it was a place of origin. In fact I was tracking that sense of origin in a more intense, emotional way than I knew at the time.

That nameless city is the one in my poems. I wish it could reliably be the one in the photographs. But I don't think it's as easy to find with the lens the way I found it with language. But now and then something quirky reminds me that fragments can point at something accurately. Which brings me to a question for you. Both of us are, in our own way, Dublin poets – or at least poets with strong ties to the city. But unlike me, you did have an Irish childhood. In your powerful poem 'The Pattern' you write about 'fitting each surprising / city street to city square to diamond'. Did having that original, childhood connection reveal the city to you, or hide it from you?

PM: *My childhood city was the north inner city – Sean McDermott Street where we lived in one of the Corporation tenement flats, the Gloucester Diamond, Mountjoy Square. My parents were back and forth to London throughout the fifties, migrant workers. I was left with my grandparents a good deal: a great blessing. My grandfather taught me to read and write quite early, so I was somewhat equipped to decode the messages I was getting from the city and from the education system. These messages were clear: the poor were corralled into poor housing, the city was divided along class lines, and you stayed in your box. As young girls myself and my classmates were being prepared for work in the sweatshops or in service: modes of being that were already nearly extinct even as we were given the last vestiges of a Victorian education. I was aware quite early that there were vastly different Dublins, depending on your address. I could be in a neighbour's flat with an old woman asleep on straw on the floor covered in old coats or walk with my father to Merrion Square to the Gallery, to the museums, or be brought to Slowey's on Henry Street by my grandmother for a new coat.*

I think why I understood your city very well as I began to encounter

it in your poems was because I realised that an accent is not a politics.
To all intents and purposes, our maps shouldn't overlap. What I love
about poetry is that it makes sectarian or sectional stances redundant.
Once, in the eighties, I was in a friend's flat when you came on the
radio, reading poetry, talking about poetry, and I said: 'I want to hear
this'. One of the women there, an activist, said, 'No you don't, listen to
that accent!' There was an argument – about class, about solidarity,
about women finding common ground. I was having this argument
everywhere, and seeing this argument everywhere. And then it was,
suddenly, both a political and a literary argument. About who writes
the city. I began to see that the city you were writing into your poems
was not a scenic backdrop for the working out of the drama of the
self, that, in fact, your relationship was with the polis, with the power
structures of the state as manifest in architecture, in statuary, in the
suffered histories of the excluded as much as in the commemorated and
sanctioned official histories. That was very attractive to the combative
young woman I was then.

EB: The city you describe in this moving way wasn't visible
to me. My father was a civil servant. Compared to other peo-
ple, we were secure. Where I could read something different
was in the life of my mother. She was a fifth child, her mother
dying at thirty-one in Holles Street and her father drowning
later in the Bay of Biscay. Much of my childhood was lived out
of Ireland. When I came back at fourteen I was just a foggy,
displaced teenager with little understanding of my surround-
ings and even less consciousness of its inequities. So the city
you describe wasn't my city. In fact the more I think about a
poet in the city – which is what we're talking about – the more
it seems to me they build one another out of the materials

they already have. In my father's background were British military men, a workhouse master, a Tipperary sergeant. In other words people who could operate the colonial levers in Ireland. Maybe for that reason when I looked at Dublin as a young poet I saw the city through that lens: as a place where colony – the layering of power over people – had happened in a very intense way. When I began to read Yeats something stirred in me about a sensibility that participates in a city's history. That doesn't just witness it. Yeats isn't a Dublin poet. But there's a fraction of his work that hovers above the city all the same. There are his angers in 'September 1913' and his bitterness in 'The Death of Synge'. From reading him and others, I was interested in looking at a city as a place where the ghosts of power are remembered and tested. For me these ghosts are often colonial. But sometimes they're just spirits of place. For all that, I distrust – for myself anyway – the idea of being a poet of place. It seems too pastoral, too remote for what I felt when I first thought of myself as a Dubliner. Yet in poems of yours – I'm thinking of 'My Father Perceived as a Vision of St Francis' – place names like Dubber Cross are braided into the lines. Would you call yourself a poet of place?

PM: *I always puzzled at being told Irish poets have a great 'sense of place'. I suspected that underneath was an unstated 'and you should stay in your place'. It felt like a simplification: like old-fashioned amateur landscape painting. It has become such a cliché that it masks, possibly drains of power, one of the most vital and crucial acts of the poet, the compact between the nonhuman and the human. Between the locale and its creatures, what waters and nourishes, as well as what threatens, what grows there. You mention 'spirit of place'*

and this rings truer to me than 'sense of place'. We can trace this aspect of our work back to the Dinnseanchas, the responsibility we once had to enshrine, possibly encode, in language the lore and etymology of place. As aboriginals sing Immrama to provide actual maps that can be journeyed on in the here and now, we, underneath all the layers of contemporaneity, real and illusory, still provide a mapping. As one might, should they frack Leitrim, reconstruct from John McGahern's stories an actual mile of hedgerow, as if he had archived it in amber. In the same way we can, from your suburban poems, say, reconstruct or conjure up out of time the forward movement of the city out to the mountains, and learn what it was like to be a woman in a kitchen in those churned-up acres with the smell of new concrete and newly mown grass under the constellations and the shadow of the mountain. I know when I read Night Feed *and especially* In Her Own Image, *I was inspired to look more intensely at where I actually was, rather than to the unreal place that I was told, in subtle and not so subtle ways, I lived in. It encouraged a generation of women, I believe, and their male contemporaries, those who were tuned in to the zeitgeist at least, to go hunt the real poems of their lives in the places where they actually lived. Do you have any sense of how you shifted the ground in this way, for those who came after?*

EB: I'm not sure I had a sense of shifting ground, either for myself or other people. But I know I felt when I came to Dundrum, and began to live a life so many other people lived, that it was largely unrecorded. Why? I think there were odd snobberies and exclusions attached to living in a suburb. When I was a student at Trinity I picked up this sense of two cities. One city gave a distinct feel of being the centre of the earth: that is, the bars, the theatres, the library, the conversations,

the events. The Dublin of writers, journalists, artists. I won't
say that it was smug. But it was definitely insular. And I picked
up something that was almost disdain for this other Dublin,
the place where I would end up living in a few years. Where
meals were put on the table, and children had to go to school,
and people had to catch the last bus, and pay their rates. It was
deemed to be anti-intellectual. And I want to be fair here. Ire-
land, in the sixties, was only beginning to shake off the grip of
small-minded conventions and over-religious influence. Writ-
ers and intellectuals in the forties – I'm thinking particularly
of *The Bell* and Seán Ó Faoláin – had done their best to open
a conversation about Irish life. So there was some honest ten-
sion between this vibrant urban centre and the more ortho-
dox perimeter where people lived so-called conventional lives.
The danger was that the first would try to ordain what was a
fit subject for literature, for poetry, and assume it could never
come from this conventional world. So when I migrated from
one world to the other, and from one part of Dublin to the
other – from being a student to being a family woman – my
sense of a divided city was very sharp. I learned to write poetry
in one. But I lived the poems I wanted to write in the other.
Now in 'The Pattern' the voice of the mother at the end says
'One of these days I must / teach you to follow a pattern'. Did
you feel any conflict in terms of living the poem, or selecting
its subject matter – between the life you came from and the
city where you began to be a poet?

PM: *We moved from the north inner city out to Finglas, to the
edge of a new estate, as I came into my teens. It was the end of the six-
ties and free education saw me in the local convent school, constantly*

in trouble, and having a great time in the new, or what felt like a new, youth culture. There was a vibrancy in music, folk and rock; in poetry, the Beats and the Liverpool poets were very influential and there were countercultural energies. This was a culture of the streets so far removed from what we were getting in school that something had to give. I was expelled by the nuns, which in retrospect was the best thing that ever happened to me: I learned the habit of self-direction and independent study. And I started writing song lyrics, which connected to my readings in the tradition, especially the Romantics, Shelley and Keats and Coleridge, and of course Yeats, who seemed a natural inheritor of their energies. From my inner-city childhood I had begun to experience the city as a palimpsest – Brendan Behan's Dublin I knew well from the tenements; and he was the first actual writer I saw – my father pointed him out to me. He was staggering from Murray's public house in Sean McDermott Street. 'A great writer, but a terrible messer' was my father's verdict. The tenement plays of Seán O'Casey were wonderfully affirmative as I had lived amongst the children and grandchildren of his characters and I never agreed with the notion that he wrote caricatures – if people have nothing except their personalities then there is an art to their being in the world which might come across as larger than life. And James Joyce, when I came to his work, had another map, more difficult but a model for an endless dance in words with the city. You can see from the names that I had no female models as writers when I was young. The only woman on the Leaving Certificate syllabus was Emily Dickinson. One might argue that her specific gravity is so intense that it would be sufficient. And of course you could sing her lyrics if you had a tune. But your mapping of Dublin in your poems, which I came across in my mid-twenties, was really the start of believing that what I might make of the inherited

patternings of my mother and grandmother, their wisdom and their silences, would be as important to me as the yang side of the legacy. And quite simply I just loved the city. Though sometimes it was very hard to live here – I had left home by the time I was seventeen and was a student at Trinity College, staying just one step ahead of the posse, always on the brink of homelessness or living in some terrible kips.

'Ireland as distinct from her people, is nothing to me', said James Connolly, another persuasive writer when I was beginning to make poems. I wanted to honour the lives I saw, lives of deprivation but also of great courage and of course great humour, which is the signature mode of the city – as I'm sure you've found yourself. I think there was a moment when I began to take the city personally. I was emotionally and psychically bound up in making a poem that would somehow resonate with the timbre of the Dublin accent itself, with the remnants of a powerful oral tradition that came to me in songs and stories and daily ramblings about the streets. Whenever I'm away and I come back it hits me, that accent which should probably have a preservation order slapped on it, it hits me in the gut. And we live in a kind of wonderful Babel now: so many languages snagging at the ear as we walk about the city. As if Finnegans Wake *has come home to us. I would prophesy that the new poetries of the city will come from out of the struggle of the new Irish to tell of their lives, their fluencies and their hesitations, with all the ghosts of their ancestors' song and poetry traditions. Do you ever get that sense that we will have new versions of Dublin beyond our wildest imaginings in the coming generations?*

EB: Cities certainly have a way of reinventing themselves. And usually from the margins, not the centre. So I'm ready to believe that some great redefining energies will come from the new Irish. It's a matter, to use your phrase, of 'taking the

city personally'. I did at one point. But I didn't have, and didn't look for, what you describe as 'the remnants of a powerful oral tradition'. Maybe I didn't have access to it. My first real connection to the city came in the years after I left school. Especially when I was a student. What I remember most is walking down from Trinity on those pre-winter evenings when there seemed to be a kind of violet-coloured, cloudy sky overhead. I would walk down Grafton Street and past Stephen's Green and on down Merrion Row towards Morehampton Road. And it wasn't a city of voices to me. It was a city of ideas, and the ideas were inside my head. Some of them were just the sparks flown off from a kind of displacement. I'd spent a good part of my childhood, in London and New York, knowing I didn't come from the places I lived in. Now, here was a place I lived in that I also came from. And yet I didn't have a history with it. I didn't have a childhood I could map onto it. So I found some comfort in making my own map back then. Printing that part of my life, in the most fractional way, on the railings, the roads, the buildings, the bus stops. It was as if I'd been dropped into a story with no chapter headings. All of this is by way of saying that my city wasn't communal as I think yours was – at least not at that point. I didn't seek to be a communal poet, which I think has been such a strength in your work. It was a solitary enough encounter for me. At least at first. And it didn't really prepare me for that extension of the city, and that disruption of it I would find later. My life in the suburb proved to be such a contrast. Suddenly – well, not suddenly, I suppose, but it felt like it – I was in a communal situation. The city all around me then, which had crept out to the Dublin foothills, was a city

of houses, families, all those tentacles of important, delicate connections. I knew perfectly well that the people I had first met, that I considered 'literary', would disdain that city. But I wanted to include it. It was now the location of my life. So that makes me curious. Did you feel there were several cities for you as you wrote Dublin poems? Or one coherent space?

PM: *Yes – cities within cities, nestled like Russian matryoshka dolls, and the myriad cities all internalised, a kind of inner city within the boundary of the skin. The poem might integrate the inner and the outer cities into a kind of ur-city. For instance, I think of a poem I wrote in 1982, 'Buying Winkles': it comes from a note in a journal of 1979, remembering a scene from when I was a child of eight; it's set on Gardiner Street, not far from Mountjoy Square where I lived in the mid-seventies as a student. There are layers of memory in this poem, people dead and alive, all looking for attention. The neighbours of my childhood would have been invisible to my student friends living on the very same street. I feel now I was constantly negotiating across the lines, translating, almost, one community to another. The poem, as it happens, found its final form in the nineties, in some quiet garden or in a coffee shop, I don't quite remember which.*

The process of making the poem is not usually happening at the same speed as is your life. Just now, I counted up the addresses I have had in the city and it comes in at around thirty. If there is a rootedness it is probably wishful thinking, or perhaps a willed and quite likely simplified narrative.

And now consider the other games that are being played, when you sit down to work with a poem: with the language itself, English and its imperial nature, our resistant version of it, the beautiful words with their own histories, their ghosts; the play with the shape of the poem,

which might rhyme or use some demented and obsessive syllabic struc-
ture (maybe just to keep from getting bored?). The way a poem lets you
hold so much in mind. That excites me. It's the hit I get from making a
poem. Why I go back again and again, craving the making.

Aren't we always making the city up? The cities?

EB: Talking about inventing cities brings me to something
else I'm curious about. Who do you think wrote well about
Dublin? Was there some piece about it that seemed instructive
to you as a poet? For myself, I can think of two examples. That
is, leaving aside James Joyce who plainly owned the city in a
defining way. But apart from Joyce here are two of the writings
I think of. The first is Beckett's 'Dante and the Lobster'. That
main character is so inward, fussy, a wonderful anti-hero of
micro-thoughts and obsessions. He ponders his lunch within
an inch of its life. He seems remote from anything practical.
But all the same, late in the story he visits the house of his aunt.
'Let us call it Winter, that dusk may fall now', he writes. And
then lists the sights he sees on the way. A horse lying down,
with a man sitting on its head. About which he puts in a won-
derful Beckett observation: 'I know, thought Belacqua, that
that is considered the right thing to do. But why?' Then there's
a lamplighter 'who flew by on his bike', and a couple standing
in 'the bay of a pretentious gateway'. The story only names
fractions of the city that identify it – like Mountjoy Gaol and
the *Evening Herald*. But it evokes the atmosphere. Then the
second example for me is Louis MacNeice's 'Dublin', where
he says almost at the outset, 'This was never my town'. And the
wry catalogue of objects and aspects that follows that – it's so
eloquent, and moving: 'She is not an Irish town / And she is

not English / Historic with guns and vermin / And the cold renown / Of a fragment of Church Latin'. And of course there were lines in the poem that especially spoke to me: 'But yet she holds my mind / With her seedy elegance, / With her gentle veils of rain / And all her ghosts that walk / And all that hide behind / Her Georgian façades'. Obviously I couldn't see Mac-Neice's Dublin in the way he saw it. He was a sophisticated migrant and an ironist. Two things I was never going to be. But when I felt like an outsider myself, having come back to the city late, and without the language of a childhood lived there, I particularly liked this passage. Were there writings on Dublin that you turned to when you thought about being a poet in and of the city?

PM: *'Micro-thoughts and obsessions' – the city moving through consciousness. Beckett said his favourite view in Dublin was up on Feltrim Hill in Kinsealy, from where he could look east and north to Portrane Lunatic Asylum – I read him with a Dublin accent, it doubles the humour.* At Swim-Two-Birds, *Flann O'Brien's meta romp, had cowboys and codders, general mayhem all over Dublin, a shaggy dog story writ large. A curious short novel by James Stephens was a set text in school and deeply affected the way I read the city:* The Charwoman's Daughter, *the chronicle of Mrs Makebelieve's grooming of her daughter, Mary, for the better things in life. The gulf between the brutal reality of her life and her dreaming aspirations for the girl struck home. Even though the novel was published in 1912 it felt like an accurate template for a kind of sad Dublin, of the thwarted yearnings that I saw around me when I was a girl.*

I found Anna Akhmatova's Leningrad or Allen Ginsberg's New York most useful as guides for making poems about Dublin. The fero-

cious and loving attention they brought to their cities was an inspiration to me. Gary Snyder's Kyoto, ancient city of Buddhist temples and modern site of Beat satori, made me determined to write a city of parks and ecstatic delight as well as tenements and the suffered histories. I loved the way Snyder saw a skyscraper as a gravel stream-bed set on edge. The way the city was also part of nature, as we are, and subject to the same forces and processes. How he saw the raw materiality of the made world, very like the way indeed your daughter of colony wears a straw bonnet made from an Irish field. Or how in your poems water is the undersong everywhere in the city and its hinterlands, an insistent reminder of source and resource.

I know you've said you are not a nature poet or, rather, that you're an indoor nature poet; and you rightly distrust the dead hand of the pastoral tradition, or its modern derivative, the mannered set-pieces of something called 'nature' as a mere backdrop to some anthropocentric, even separatist stance.

One of the most powerful elements in this selection of your city poems is the appearance, the manifestation even, of those two ghost wolves at the very edge of the city in the poem 'Once'. As if they had strolled out of aboriginal mind, which I believe to be the antithesis and possibly salvific antidote to the institutionalised mind. As if they had urgent news for us. They break my heart.

> Irish wolves. A silvery man and wife.
> Yellow-eyed. Edged in dateless moonlight.
> They are mated for life. They are legendary. They are safe.

The way they come out of the ghost forest that was once your suburb of Dundrum, how you recreate the thrushes that sang in the ghost tree

where your house now stands. The coming together of these histories in place, histories human and creaturely, amplifies our vulnerability, intimates our own threatened survival.

EB: 'Threatened survival' is such an interesting phrase. And together with it, you mention a name there that belongs with that idea, a poet we both admire: Anna Akhmatova. In her poem 'Epilogue to the Requiem' she writes about St Petersburg, although at the time of the poem, in the early 1940s, it was Leningrad. She describes the Stalinist Terror, the endless lining up at the prison gates, where her son was, the sounds of anguish in the prison queue. She ends by saying that if they ever want to make a statue of her, it should be placed near the prison gates where she shared that ordeal with others. One translation reads: 'Lest in blessed death I should ever forget / The grinding scream of the Black Marias'. I think of that because it's a gesture that radicalises a poet's relation with a city. That makes the reader see a different reality. It shows Akhmatova's willingness to see a city within a city. After all, as a young woman and a young poet in the Stray Dog Cabaret she lived in an entirely different place: bohemian, welcoming, exuberant. I'm interested in that idea of a city within a city. Sometimes in Dublin I see traces of a colony within a colony. It's still striking to me that the statues of male writers and orators in Dublin are official, named and legible. Kavanagh by the canal. Oscar Wilde. Grattan. Burke. O'Connell. Parnell. But the women statues are women out of a song, like Molly Malone, or out of a place myth like Anna Liffey, or anonymous like the two women chatting on the bench. I think that my original uneasiness when I went from

being a student to living in a suburb had something to do with my sense that the bias against the dailyness of an ordinary neighbourhood, in terms of art or ideas, was a sort of extension of a colonial attitude. In Akhmatova's case, speaking of a city within a city, there's a clear fracture between her first graceful, bohemian city and the dark prison of Leningrad during the war. Here in Dublin I can connect the historic city with the present-day one. When you think of your relation to Dublin, the city you write about, is it always in the present? I think of you as staying in that zone a little bit more than I do. My poems wander a bit more backwards. But I know you've been acutely aware of the history of the city in your poems both as art and architecture.

PM: *There's a fine bust of Constance Markievicz by the Cork sculptor Seamus Murphy in St Stephen's Green, but you're right, there's a paucity of memorials to actual women. I love Rachel Joynt's sculpture on the southern side of O'Connell Bridge. Its footprints, paw prints, shoe prints, heel prints, high-heel prints, bird tracks, cat tracks, in various metals laid flush to the concrete of the traffic island. I love it because it's not an erection – you have to be crossing the road to actually see it and you see it best by walking over it. And it captures perfectly the random contacts and passings that one makes in the city. And, remarkably, we will have the Rosie Hackett Bridge, our newest bridge over the Liffey connecting Abbey Street to Hawkins Street and named for a lifelong trade unionist and member of the Irish Citizen Army.*

I'm very interested in what you say about the traces of colony you found and find – a hurt or wounded city within the quotidian city. There's a sense always in Dublin of the traumatised city: it hovers in a name change perhaps, New Brunswick Street becomes Pearse Street,

Rutland Square becomes Parnell Square, it shimmers around erosions and accretions both. James Joyce Street now where we had Montgomery Street, in the heart of the old red-light district. I have a family connection there – my great-grandmother Anna Meehan was a madame at the turn of the nineteenth century when Monto was the biggest red-light district in Europe. A hidden history in our family; I came to it late when Terry Fagan of the Inner City Folklore Project walked up to me one day and said, 'I've great stuff on your great-granny'.

I know I've been accused (and accused is the accurate word) of something called identity politics in my poetry and I know you have too. Poems of yours like 'Making Money', a true act of empathy with the paper mill workers of turn-of-the-nineteenth-century Dundrum, a poem wonderfully rich in the detail of the toxic process and drudgery of making paper for the printing of bank notes, for an empire gearing up for a war that would render the bank notes themselves redundant. I was astonished at the negative reaction to that poem. You were accused (that word again!), bizarrely, of appropriating the sufferings of those women. Why do you think an act of compassion would so annoy a critic?

I remember a girl in my class in the Central Model Girls' School, a beautiful child called Clare, who died of diphtheria in the early sixties. Diphtheria! She lived in a two-room flat with her parents and twelve siblings in Corporation Buildings. That experience and many others like it haunted, and I believe formed, my imagination. Why shouldn't I remember Clare in a poem?

The seven tower blocks of Ballymun, named for the executed leaders of the 1916 Rising, became a byword for disastrous urban planning within one generation. Ill-conceived, ill-managed and eventually demolished. We played as young teenagers in the foundations, having

walked across the back fields from Finglas. Am I supposed not to remember this, to speak of this?

Then there were the inner-city flat complexes named for Marian shrines and Catholic saints: Lourdes House, Fatima Mansions (where I lived for a few years in the eighties), St Mary's Mansions: communities in crisis as traditional sources of work in the city disappeared. You'd need a miracle to get housed out of them was the joke. I remember attending funeral after funeral, burying the brightest and the best of the kids as heroin swept like a juggernaut through the poor communities. Should I not speak of this?

I had to believe that there was a home in poetry for the lives I saw about me. I had to believe I could find a language to honour the courage I saw everywhere.

And to loop back to your question – I saw the historic city as something you could read like a text, that would, through close study, yield up its mysteries, and make sense of the sociology, if you like, of the lives I witnessed. The deeper I dug into the past of the city, the more sense I could make of what I was seeing lived out in the present moment.

To walk the streets of the city was, is, to stroll at will through the layers of its making and its peopling, to learn to place a particular building within its era, to see the lineaments of the Viking city, the Christian settlements, the Norman castle, the Georgian mansions, and then the famine cabins of the backstreets, the stables and abattoirs down the mews lanes. All that, and always the lives lived there.

But, I have a sense also of something else at work – a kind of dream city or dreaming city. It doesn't exactly map on to any known verifiable place. It's the private sonic Dublin each poet makes – the individuated song of the self in place, the free self in the given place. Maybe that's our true city?

EB: In her book of essays *Blood, Bread and Poetry: The Location of the Poet*, Adrienne Rich has a powerful statement about poetry and politics. And it touches on 'appropriation'. Here's what she says: 'There were as many voices then, as there are now, warning the North American artist against "mixing politics with art." I have been trying to retrace, to delineate, these arguments, which carry no weight for me now because I recognize them as the political declarations of privilege'. Rich goes on to say that maybe many 'fear an overtly political art because it might persuade us emotionally of what we think we are "rationally" against; it might get to us on a level we have lost touch with, undermine the safety we have built for ourselves, remind us of what is better left forgotten'.

I agree with Rich. Critics who attach the word 'appropriation' to subjects that make them uncomfortable tend to be white, academic, and they usually aim the argument at women. And that simply isn't a sophisticated or textually sound approach to a poem. A poet should have whatever licence he or she needs to broaden the poem in a political or public way. Some of the most powerful poems of the century come from that broadening – Ginsberg's 'Howl', 'North American Time' by Rich, 'Sunday Morning' by Lowell.

Of course, it's ridiculous to think a poet like yourself could be open to those censorships. But let's not forget that one noted critic wrote at the time of publication about 'Howl': 'It is only fair to Allen Ginsberg . . . to remark on the utter lack of decorum of any kind in his dreadful little volume'. And this was in the *Partisan Review*. So critics about to launch criticisms

at political or public poetry should read that line and pause. Ginsberg's 'dreadful little volume' went on to define the innovative, committed public poem for our time. The critic did not.

I think for any poet writing about a city, the balance between public and private becomes key. That's why I'm so interested in your comment about a city that 'doesn't exactly map on to any known verifiable place'. I think any poet can have that dream city. Some of *Ulysses* gets its great texture and sweetness from the dream city at the beginning. And when Stephen Dedalus begins his great walk through the city in *A Portrait of the Artist as a Young Man* it seems to be half a dream. Then again in 'The Dead' the real city of music, posture, conversation, food and conviviality gives way to that dreaming, snowy Dublin in which revelation happens. I'm curious. Is Joyce's portrait of Dublin one you found instructive?

PM: *I loved* Dubliners. *To walk the named fictional streets and the real streets as I was reading it, so many of the buildings extant before my eyes, was really exciting, quite apart from the characters, types easily translatable to the characters I saw around me. Joyce's north cityscapes themselves were intact if you squinted past Busáras and Liberty Hall and didn't stray too far beyond Glasnevin.*

But there's a strange thing: I heard Ulysses *first before I read it. One long winter with no money, no television, no phone, before mobiles or Internet, it was read to me; sure what else would you be doing? The perfect virtual experience. What abundance now to remember! When I came to the text I found it a hard read, harder to read than to listen to. Joyce must have heard them very clearly, the voices of the city, his remembered city: such prodigious recall and invention. But*

Finnegans Wake *is of a different order of challenge. It demands a huge amount of surrender. Surrender just to the heft of it as sound; as text it can sometimes feel more like the experience of doing a cryptic crossword.*

Olwen Fouéré has made a theatre piece of a section of the novel – and in a sense it will always be a work in progress for its readers. I think it will be mined and retrieved and deconstructed and reconstructed and retrofitted for generations to come. I felt that Finnegans Wake *was making me up as I read it.*

Here's a question for you: would you have written very different poems if Joyce had not so exhaustively written the city? And perhaps a second question: did you ever find yourself writing, or find you had written, in counterpoint to Joyce? Is he a ghost you'd tangle with in the way, say, you so obviously tangle with Yeats?

EB: I first came on Joyce in a roundabout way. I was back in Ireland, at boarding school in Killiney. My godparents lived in Sandycove, and I visited their house often because I was a friend of their daughter. The owner of the house, my godfather, the architect Michael Scott, had bought and built on that land in the 1940s – right there in Sandycove – and the Martello Tower went with the purchase. So there I was at about fifteen, lucky enough to be able to go up to the top of the tower often, and in different seasons, and look out at the view Stephen Dedalus sees in the first chapter of *Ulysses*. It was one of my first panoramas of the city. The long view of Sandymount Strand in the distance, the harbour and, of course, Stephen's 'bowl of bitter waters'. A little later, as a teenager trying to read *Ulysses*, a fair amount of it defeated me. But the first part was always crystal clear, maybe because I could visualise it from

those times standing at the top of the tower. It was the first time I had the experience that gradually led to my realising that a city could be mapped, not just by cartography or history, but by instinct, memory, passion. That certainly had an influence on me. But to answer the question, I don't think I ever wrote in counterpoint to Joyce. Nor was he a ghost I tangled with. I thought of him as a writer who had lent extraordinary dignity to the city we all lived in by mapping it with his losses and his feelings. But I saw a different city. Because I was a young woman, when I started, very unsure where my name could be found, or – to put it more exactly – fairly sure it couldn't be found, I saw a city where inscriptions of authority and power, of colony and history were everywhere. It made me think and keep on thinking. Who exactly writes a city? When I was seventeen I had a summer job at the Gresham Hotel. It comes into one of the poems here, 'Unheroic'. When I came out at the end of the day I sometimes looked at Parnell's statue with the inscription 'No man has a right to fix the boundary to the march of a nation'. I came to feel very resistant to that rhetoric. The city I began to build for myself was seen through that resistance. So Joyce was a gift and a grace but not in any way a Jacob's angel.

PM: *I'm sitting in the back bedroom of the house with a rough version of this book printed off* (plain paper, fast, black and white). *Your poems and photographs cover the floor. I have spent the last while arranging and rearranging the running order. Soon I will talk to Jody who is in New York and we will no doubt shift and rearrange again as we have all been doing over the last while. There's the statuary – Emmet, O'Connell. There are the made images – Anna Liffey's river*

head wired up for illumination, a portrait your mother Frances Kelly painted, of you with one of the dolls from a collection she later gave to the Dolls Museum. The dramas of the poems are set against these peaceful, composed photographs, distanced in black and white. Text ironises some of the images. You may not be an ironist in poetry but the photographs are loaded: 'Ailesbury' carved in granite in a suburb, Dundrum, which translates as the Fort of the Ridge, the ghost of colony spilling out into the suburbs laying a pretentious naming over greenfield sites. 'Meadowbrook' – how far from Cluain Abhainn or any native under-naming? Was there a meadow? Was there a brook? The mother tongue displaced in the Pale by the stepmother tongue of empire. And then the image of the text of 'Dundrum Town Centre', signage that surely signifies late-century capitalism, mall culture. And the quote from Damien Dempsey's song lyric painted along the docks in retro Dublin lettering, a homage to the signwriters of our childhoods from the artist Maser.

And those two heart-breaking monuments to lost children: the plaque of your poem 'Tree of Life' in Merrion Square (Archbishop Ryan Park, to give it its official name) that commemorates the babies who died in the nearby National Maternity Hospital. And the monument to the victims of the 1974 Dublin and Monaghan bombings that accompanies your poem 'Child of Our Time'. That sad roll-call of names whose families still haven't had justice, still no proper calling to account of the perpetrators of those murders and their enablers.

And here, as elsewhere, the monument speaks to the living memory. I remember that bombing as a huge trauma for the city. Everyone was connected to somebody who was affected either directly or indirectly. I narrowly missed walking into the Lincoln Gate explosion and I finally understood what it must be like to live in a city during a war. It made

a lifelong pacifist of me. And though you may not be aware of this,
many people took ownership of your poem; I saw it torn from the news-
paper and thumbtacked or sellotaped up on many walls. Some years
ago when I was involved in a commemoration for the victims, it was
still on the lips of the bereaved families. It meant such a great deal to
them, and still does.

I have always sensed that poetry is public speech. A communal art.
You spoke once of the journey being one from self-expression to art.
I experience poetry as public speech. It pre-dates literature. It's not
the same thing as literature, though since moveable type was invented
it has had a long and fascinating relationship with the book. What
it carries over from its oral days can sometimes be mere ornament
or mannerism. But even where on the surface it deals with private
narratives, or coded, secret narratives, even where the poet pushes
the language itself to the edge of glossolalia or, as Beckett might put
it, divine aphasia, the poem still desires another human consciousness
to resonate with or through.

EB: I admire that definition of a communal poet and it
seems in keeping with how you see poetry as public speech.
I hesitate around those issues, although I think the conversa-
tion about a communal art is important. It all depends how
you think about the word, even the concept. That adjective
'communal' has a related verb – an old-fashioned one – which
is 'communing'. A word I've always loved. And one, when you
look at it, that's quite a bit removed from the adjective that
seems close to it. For me, even when a poem is not apparently
communal, even when it seems to be private, it can still com-
mune. In fact it may make a particularly strong community
with a reader, and still not be communal, just by speaking to

and of solitude. That communion seems to me valuable: truly one of the great possibilities for the poem. But I don't think of it as public speech. So do we differ on that? We probably do. And that seems a very good moment to approach the end of this conversation on the city, which I've so enjoyed. Because if we differ, it only proves again what we already know: that Dublin is a chameleon city – one that's always generated different writing, different perspectives, different poems, different poets. Which is as it should be.

NOTES ON THE PHOTOGRAPHS

p. 2: Atlantis – A Lost Sonnet

Fanlights were and are a distinctive feature of Georgian Dublin city architecture. These windows were first seen in England in the Georgian period and the term 'fanlight' came into use at the end of the eighteenth century to describe a window with panes in a fan-like shape. In the houses around Merrion Square and Fitzwilliam Street, as pictured here, they make a distinctive semi-circular window above the doorways.

p. 8: Unheroic

The Gresham Hotel – referenced in this poem although not named – is at the far end of O'Connell Street. The hotel was purchased in 1817 by Thomas Gresham. In Irish literature the Gresham is the hotel in which James Joyce's characters from *The Dead* – Gabriel and Gretta Conroy – take a room for the night. The location sets the scene for a celebrated moment between husband and wife. Joyce's story provides an atmospheric description of the hotel as it once was: 'An old man was dozing in a great hooded chair in the hall. He lit a candle in the office and went before them to the stairs. They

followed him in silence, their feet falling in soft thuds on the thickly carpeted stairs'.

p. 10: The Huguenot Graveyard at the Heart of the City
The small Huguenot graveyard in Dublin, a few doors down from the Shelbourne Hotel, links Stephen's Green with upper Merrion Street and Ely Place. The cemetery can be seen through iron railings, although the space provides little light for the graves and inscriptions. It dates from 1693. The Huguenots fled France after the revocation of the Edict of Nantes in 1685 to avoid forced conversion to Catholicism. They established a thriving community in Dublin and Huguenot names are still threaded through Dublin family histories.

p. 14: City of Shadows
The statue of Daniel O'Connell, a nineteenth-century Irish nationalist leader and architect of Catholic Emancipation, stands at the entrance to the street re-named for him in 1922. A subscription for it was opened in 1862. The monument itself was created by the celebrated sculptor John Henry Foley, who died in 1874 before it was completed. When it was inaugurated in 1882, the *Freeman's Journal* noted that the statue recorded 'the gratitude of the Irish people for the blessings of civil and religious liberty obtained for their native land by the labours of the illustrious O'Connell'.

p. 16: A False Spring
The Trinity College Reading Room, referred to in this poem and pictured here, is on the Trinity College campus. It is a distinctive, small building and easy to overlook among the more imposing buildings of the College's Front Square. The building is unusual in that it serves both as a reading-room and a war memorial. The

memorial was unveiled in 1928 to commemorate the 463 Trinity men who lost their lives in World War 1. In 1937 the reading-room of the building was re-opened by Eamon de Valera.

p. 20: Tree of Life
The poem in this photograph is etched in stone relief and set into the ground in Merrion Square in Dublin. The poem was commissioned from Eavan Boland by the National Maternity Hospital in Holles Street to commemorate the lives of the infants who had died or been stillborn at the hospital. At the remembrance service each family or parent who had lost a child planted a snowdrop and the flowers come up in early spring.

p. 22: Nationhood: Two Failed Sonnets
The Speranza referred to in this poem was the pen name of Oscar Wilde's mother, who lived from 1821 to 1896. She was a nationalist poet and an activist. Oscar Wilde was born in 1854. He moved with his family when still an infant into number 1 Merrion Square, pictured here. The windows overlook the private, leafy space of Merrion Square gardens. The house is considered a prime example of Georgian architecture with its ironwork and tall windows. In Wilde's childhood, it was a centre for intellectuals, writers, celebrities and politicians.

p. 26: The Dolls Museum in Dublin
The Dolls Museum of the poem's title was located for several decades in a private house in Palmerston Park in south Dublin. Dolls from various periods were shown dressed in the fabrics and costumes of their time, and placed in large glass cases. The exhibits had a historic and cultural value and the museum was a tourist attraction. It closed at the end of the 1990s. The painting in the photograph is a

painting of Eavan Boland as a child, done by her mother, the artist Frances Kelly.

p. 28: An Elegy for My Mother in Which She Scarcely Appears
The photograph here is of Macartney Bridge, named for the chairman of the Grand Canal Company which oversaw the bridge's construction in 1791. It is known to Dubliners as Baggot Street Bridge. The Grand Canal is one of two city canals which connect Dublin to the Shannon River through a complex network of villages and rivers. Until 1960 this canal was a working waterway with cargo barges. A life-size statue of the poet Patrick Kavanagh is seated on the towpath a little further down. He wrote of the canal: 'O commemorate me where there is water.'

p. 36: Heroic
Robert Emmet's statue stands in Stephen's Green. It faces a site where his family house once stood. He remains an icon of Irish nationalism, executed at the age of twenty-five in 1803 for high treason in leading a rebellion against Britain. The statue was cast by the sculptor Jerome Connor. It was finished in 1916, in the year of the Rising. Both the year and the statue evoke Emmet's words at his trial: "When my country takes her place among the nations of the earth, then, and not till then, let my epitaph be written."

p. 38: Child of Our Time
In May 1974 Dublin was bombed by paramilitaries from the North. One of the locations most damaged was Talbot Street, north of the Liffey. Here a baby was lifted from the rubble by a fireman. The infant was already dead. The photograph of the fireman and the baby was an image on the front pages of newspapers the following day.

The poem 'Child of Our Time' was written within days and published some days later in the *Irish Times*. The names of victims are remembered today by a monument at the end of Talbot Street, as seen in this photograph.

p. 40: Canaletto in the National Gallery of Ireland
The dome of the Custom House – visible in this photograph – is a landmark sight in Dublin's city centre. Construction began in 1781 and was supervised by the noted architect James Gandon. Its original purpose, which was for collecting custom duties, became obsolete as the port of Dublin shifted downriver. In 1921 the Custom House was burned down in the War of Independence by the IRA as part of their opposition to British rule. Centuries of parish records and local histories were destroyed in the fire.

p. 46: The Scar
The photo here shows a granite profile of Anna Liffey on the bridge that spans the Liffey. The bridge itself is about fifty metres wide. First known as the Carlisle Bridge, it was designed by James Gandon and completed in 1794. In 1882 it was renamed O'Connell Bridge in honour of Daniel O'Connell whose monument is nearby. At the centre of the bridge is the head of Anna Liffey, who personifies the river.

p. 50: Anna Liffey
The river Liffey rises in the Wicklow Mountains and flows down through Wicklow, Kildare and Dublin until it enters the Irish Sea in Dublin Bay. The river has had several names in Irish. In English it has been feminised as Anna Liffey, probably derived from the Irish phrase *Abhainn na Life*. James Joyce's character Anna Livia

Plurabelle is a reference point in his final novel, *Finnegans Wake*. He wrote of her as the past and future of the city: 'Anna was, Livia is, Plurabelle's to be'.

p. 60: How the Dance Came to the City
In the last years of British rule in Ireland the colonial administration in Dublin Castle still guided the fashionable life of the city. Dances, balls, coming-out presentations were a part of that life. The dance cards in the photo here are dated a decade before the 1916 Rising. Like the dances referred to in the poem, they suggest the persistence and energy of a ruling class, seeking its pleasures, maintaining its privileges in the final days of colony.

p. 64: The Harbour
Dun Laoghaire – or Kingstown as it was once called – provides a major port of entry into Ireland from Britain. It is nearly eight miles south of the city centre. Its construction dates from 1816 following a shipping disaster which proved the need for a harbour. With the visit of King George IV in 1821 it became known as Kingstown and throughout the nineteenth century it was a central emigrant port. In 1921 it was re-named Dun Laoghaire. The area provides a fine prospect of Dublin Bay and the Wicklow Mountains.

p. 78: Cityscape
The site in the photograph is all that remains of the Blackrock Baths which for years were a resource for Dubliners. In 1834 a local company decided to construct 'a Promenade Pier and suitable Bathing Place for the residents in the locality and for the use of the public at a point near Blackrock Railway Station'. The baths and the diving station that went with them provided a landmark recreation in

the late nineteenth century and well into the twentieth. But by the 1980s they had become derelict.

p. 82: Under These Hills

Dundrum, now a busy suburb south of Dublin, was once typical of the neighbourhoods which offered a leisured class – mainly Ascendancy and Protestant – rest and recovery. The old stone inscription in this photograph of 'Meadowbrook' survives from the start of the nineteenth century. A newspaper in 1813 carried an advertisement for what was obviously an annual health cure: 'The second whey season having commenced, Ladies and Gentlemen are respectively informed that there are a few vacancies in the house'.

p. 86: The War Horse

The wooden figure here of a horse was made in response to the poem 'The War Horse'. It was carved by the celebrated Irish sculptor Oisin Kelly who also made the monumental sculptures of the Children of Lir in the Garden of Remembrance near Parnell Square. The wood, as he described it himself, was taken from the same wood as was used to sink pylons in the sea.

p. 96: The Mother Tongue

The Pale referred to in this poem is a term from Irish history. It refers to a territory under British control and was known in Irish as An Pháil Shasanach. In 1450 several versions of these boundaries were established, one in Dublin. The Pale was prescribed to be a double ditch of six feet high above the ground at one side or part which *mireth next unto Irishman*. It was to keep out the 'mere Irish'. Hence the vernacular phrase: *beyond the pale*. Today traces of the Pale are hard to find in Dublin. But they do exist. This small monument,

in the midst of suburban houses, near Sandyford in south Dublin, looks back to a different past and a subject nation.

p. 102: In Our Own Country
The 'emigrant boat' referred to in the poem references the Irish Famine. In 1846 and 1847 the failure of the potato crop led to widespread starvation in Ireland. This monument, by the sculptor Edward Delaney, commemorates those who suffered and died in the famine. It can be found in the north-eastern corner of Stephen's Green.

pp. 106: Making Money
South Dublin and the neighbourhood of Dundrum were locations for many kinds of mills in the nineteenth century. One was a paper mill. The paper was of such high quality that it was used for printing bank notes. The Slang River, a tributary of the Dodder which flows through the south suburbs of Dublin, was harnessed by the mill. The small cottages pictured here housed the women who worked there. The sulphates used in paper production were not yet recognised at that time as hazardous to health.

p. 118: Re-reading Oliver Goldsmith's 'Deserted Village' in a Changed Ireland
The south city, referred to in this poem, was a place of linen mills, paper mills, textile mills. The Dundrum Town Centre in the poem, now a thriving shopping location, was once the old Manor Mill Laundry. In the 1930s a water turbine was installed for generating electricity. The laundry closed in the 1930s and became an electronics factory. Oliver Goldsmith's poem 'The Deserted Village', published in 1770 and based on the decline of an Irish village, is echoed here in the references to daily shoppers walking over a history no longer visible to them.

INDEX